Magic Realist Painting Techniques

BY RUDY DE REYNA

WATSON-GUPTILL PUBLICATIONS/NEW YORK

PITMAN PUBLISHING/ LONDON

First published 1973 in the United States and Canada by Watson-Guptill Publications,
a division of Billboard Publications, Inc.,
One Astor Plaza, New York, N.Y. 10036

Published simultaneously in Great Britain by Sir Isaac Pitman & Sons Ltd.,
39 Parker Street, Kingsway, London WC2B 5PB
U.K. ISBN 0-273-00411-5

Manufactured in Hong Kong

Library of Congress Cataloging in Publication Data
De Reyna, Rudy, 1914–
 Magic realist painting techniques.
 Bibliography: p.
 1. Magic realisms (Art) 2. Painting—Technique.
I. Title.
ND1505.D47 1973 751.4'2 73-6929
ISBN 0-8230-2956-5

First Printing, 1973

To my daughter Mandy

Acknowledgments

Again, I should like to express my debt and gratitude to my editor, Diane Casella Hines for doing such a splendid job in giving order and lucidity to my wobbly words.

Contents

Introduction

"Magic Realism" is an approach to painting that goes back half a millenium to the Florentines and the Flemish. Long ago it had its devotees also in this country, drawing to its ranks such illustrious names as Church, Harnett, Bierstadt, Eastman, Eakins, and secondary lights I needn't mention. Currently it is Mr. Andrew Wyeth who has, in my unshakable opinion, advanced this style of painting to the eminence it occupies in American art today.

The magic realist approach holds a "mirror up to nature" to record the minutest detail, but unlike the *trompe d' oeil* American paintings of the 1880's and 1890's, it doesn't "deceive the eye"; it enchants the eye. With this approach you exalt the subject instead of extolling the hand that makes it. Yet, paradoxically, once you master the "magic realist" technique, it will thrust you (or rather your paintings) into the spotlight even if you'd rather remain in the wings.

This technique is now being practiced by many artists in a variety of media—egg tempera, gouache, and casein. Such media make it possible to render the meticulous detail that is the hallmark of magic realism. Our technology has also given us acrylic paints which are now widely used for this type of work. All these media are water soluble and make possible the precise brushwork needed to create fine detail. Another advantage is that these media dry so quickly that the artist can swiftly build up the elaborate textures so characteristic of the tempera technique.

In this book I'm going to present projects that will help you manipulate the media just mentioned to create this kind of "magic realism." The projects start off in black and white with simple procedures such as drybrush, scraping, and sponging off. Then the projects gradually get more complex, demanding more of your skill, and ending with eight projects in full color which present the particular problems that color introduces.

By the time you finish this book, I hope you'll have mastered the basics of all the various techniques and media presented here. These techniques will help you create some "realistic magic" of your own.

Media, Materials, and Techniques

For magic realist painting you must use one of the water-based media-egg tempera, opaque watercolor (gouache), casein, or acrylic. Of course, with these four media you use water to mix them to a painting consistency, hence their generic name, "water-based media." These media all have two components. They all consist of powdered pigment (which gives them various colors), and a binder or vehicle (something to make the pigment adhere to the painting surface).

It's this latter ingredient that varies among the four media. Egg tempera, as its name indicates, uses the yolk of an egg as its binder; opaque watercolor has gum arabic as a binder. Casein contains casein glue as a binder. This glue is an organic compound that derives from lactic casein. Acrylic paints utilize an acrylic polymer emulsion as their binder.

These media and the materials and tools you'll need to work with them will be presented along with specific techniques for utilizing these media.

EGG TEMPERA

The traditional egg tempera is a compound of dry pigment, water, and egg yolk. The egg yolk acts as the binder that holds the pigment to the painting surface. I obtain my dry pigments from Grumbacher Inc. I must caution you *not* to use the dry tempera colors packaged in one-pound containers. I mention this because such a product is the first thing the art-supply salesman thrusts upon the amateur.

PREPARING EGG TEMPERA

First, I break an egg into halves over the sink. As I shift the yolk from one shell to the other, I let the whites slide out into a small container. Then I turn on the water slightly so that its flow doesn't break the yolk. I keep shifting the yolk from one side to the other, close to the tap, and wash away the remnants of the white. When the yolk is thoroughly washed, I hold it by its "skin" (membrane) over the container I'm going to use and pinch this skin hard enough between forefinger and thumb so that it breaks, releasing its contents. I hold on to the membrane of the yolk, so I can discard it. Then I add three teaspoonfuls of water from the tap to the yolk and stir. Some artists add a few drops of vinegar so that the yolk won't spoil. Some even use distilled water instead of tap water, but I'm not that fastidious.

Next, I pour small amounts of the powdered pigments into their respective china cups, or other containers, which I place on my butcher's tray. I add a teaspoonful or two of egg yolk to each dish, depending on the amount of pigment in it. I begin to stir the pigment and yolk with an old brush, from (white) the lightest to the darkest (black) rinsing the brush every time I move on to the next dish.

OPAQUE WATERCOLOR

This medium is also called gouache and tempera because it resembles so closely the egg tempera that the artist makes himself. The dif-

ference is that opaque watercolor comes in tubes and jars, already prepared. Instead of egg yolk the binder in opaque watercolor is glue. I use Designers' gouache, which comes in tubes, because the manufacturer marks the permanent colors, with an (A) and the semi-permanent with a (B). Colors that are neither permanent nor semi-permanent are marked with the warning: "This color is fugitive." All grades are excellent for commercial work, but if you're addressing yourself to posterity, as all of us hope, better stay with the "permanent" palette which contains many hues.

Opaque watercolor also comes in tin boxes made by several manufacturers and these are interchangeable with the tube colors. My favorite brand in a tin box is Marabu because of its wide range of yellows, greens, and blues. I use it exclusively when sketching outdoors and sometimes even in the studio for smaller paintings. The small tubes of white supplied with these tin boxes are soon exhausted, but I supplement these with Designers' Permanent white, or Artone's

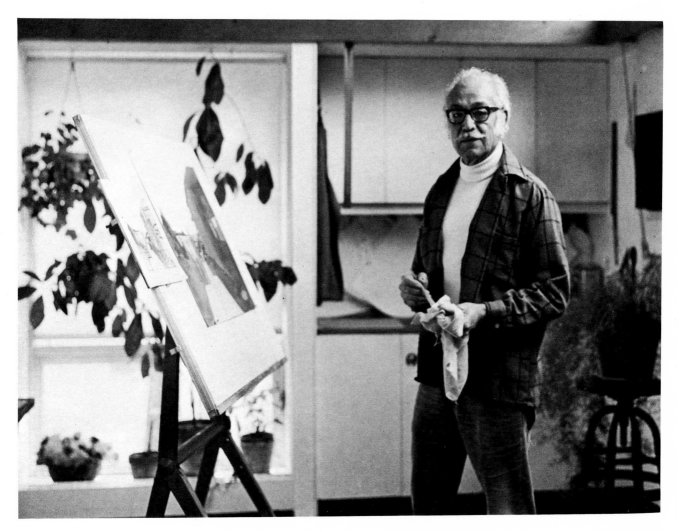

My Studio. Here you have a good view of my drawing table. As you can see, I prefer to stand while I'm working. The plants in the background give me "spiritual sustenance."

white because of the marvelous opacity of these whites. I use regular watercolor brushes with opaque watercolor.

For the first project in this book, you'll need a tube of black and a tube of white opaque watercolor. Grumbacher puts out a good black and a good white opaque watercolor under their brandname Gamma. Weber has a first-rate black and white in their Permo-Gray line. Try to get these if you can. If what you want isn't available, you can settle for a second-rate paint. However, don't compromise on the quality of your brushes which should always be the best obtainable. There's nothing more exasperating than working with a second-rate "bunch o' hairs" on a stick.

CASEIN This medium contains the same powdered pigments that enter into the composition of the other four magic realist media used in this book. However, the chemistry of casein differs. It derives its name from the albuminous product (akin to the white of an egg) that serves as its vehicle or binder (just as egg yolk serves as the binder for egg tempera. Shiva's and Grumbacher's casein paints are first-rate, and I use both brands, sometimes even interchangeably. Casein is the most inviting and alluring of paints. Its viscosity, as it comes from the tube, is positively irresistible.

I always immediately want to cover the largest canvases with it, just to revel in spreading the stuff with my biggest brushes. But let me quickly add that I also find it disobedient and reluctant to do my bidding in the type of painting that I'm demonstrating in this book. Casein is difficult to manipulate because the pigment accumulates on the brush even after rinsing, and it must be washed off with soap as I paint. Yet, it's the medium I come to when I become too glib with the other media that give me no argument. I can "say" or do anything I want with them without the slightest protest, and truthfully, it becomes a bit boring. I like casein because to control it taxes all my resources, and the artist must have control of it in order to get the minute detail and the gradual build-up of paint that "magic realism" demands.

ACRYLIC The versatility of this medium is making it more and more popular. You can dilute acrylic paints with water to the thinnest consistency and use them like transparent watercolor. You can also use acrylic straight from the tube for an impasto and create arresting textures without fear of cracking. Acrylic can give you the cleanest, thinnest, and most precise line and the hardest and sharpest edge. You can glaze over an acrylic underpainting immediately without fear of picking it up because acrylic paint dries so quickly.

Acrylic comes already prepared in tubes and jars. It's permanent and water-resistant (although it's water soluble when you're paint-

ing). There's a whole array of pastes, emulsions, and varnishes sold that are compatible with acrylic and make this newest of media fascinating to handle and explore. I use either "Hyplar" acrylic paints by Grumbacher, Inc. or "Liquitex" acrylic paints by Permanent Pigments, Inc. They're both excellent brands.

MIXED MEDIA The purpose of using a combination of several media is to achieve particular effects unobtainable with any one medium alone. For example, you can underpaint with acrylic and then glaze and scumble over it with egg tempera. The effect created couldn't be obtained by painting directly with either medium alone.

There's hardly any limit to the number of media that can be combined to execute a painting as long as each one aids and supports those that follow. A painting can begin with charcoal directly on the support. You can follow this charcoal sketch with India ink to secure the drawing, so that you can wipe off the charcoal. You can follow in turn with egg tempera which you can glaze and scumble with acrylic.

I've combined casein and acrylic in Project 9 because I wanted the casein ground to pick up and "fog" the acrylic which I worked vigorously over it. Then, as I continued to work, the acrylic became water-resistant and I could continue glazing the "veiling" with light tints over the dark acrylic areas without disturbing them.

WHERE TO BUY You can find all the painting media just discussed, and the materials and tools that follow, in any good art supply store. If you don't have one nearby, I suggest you write for a catalog from such a store in a large city nearest to you. These catalogs scrupulously describe each item the art supply store carries, so that you can select exactly the equipment and materials you want. I love to pore over these catalogs, because they sometimes suggest a tool or painting surface that I wouldn't have considered. For example, I discovered a tool called a "frisket knife" which makes better incisions than the ones I can make with a razor blade.

MASONITE Just as you select a certain medium because it lends itself to particular effects and helps you capture the character of specific subjects, you must also choose the ground or support that will facilitate use of the selected medium. Masonite panels are terrific for egg tempera or gouache after you prime their smooth side with acrylic gesso. Masonite panels provide a firm surface. The panels can be cut to whatever size you want right at the lumberyard. I use either ⅛″ or ¼″ thick Masonite (you can also use ¼″ Presdwood). I reserve ¼″ boards for my larger paintings. I always take care to give the reverse side of the Masonite panel (grilled) at least two coats of gesso so that it won't warp or buckle.

I use Liquitex white acrylic gesso for my primer and apply it to the Masonite panel with a 2″ housepainter's brush. I brush the gesso on alternating the strokes horizontally on one coat and vertically on the next. After one coat has dried, I sand it and then apply the second coat. You can leave your brushmarks in the priming gessk for texture, or you can continue sanding the gesso until it has a smooth plate finish, if that's what you need.

CHIPBOARD This is a gray, thick, uncoated cardboard used for mounting pictures, but I like its color and its surface. Sometimes I paint directly on it using its gray color as part of the color scheme of my painting. At other times I give the chipboard a coat or two of acrylic paint (on both sides so it won't buckle) in either white or the pervading color of the painting I propose to do. You can use all water-based media on it.

ILLUSTRATION BOARD The kinds and varieties of this support are so numerous that I couldn't begin to list them. However, I have described in the projects of this book the brands I've used. Illustration board can be used with all the "magic realist" media, and can be coated with any tint or shade that you desire. This is especially useful when you're working in egg tempera. You use it as it comes from the manufacturer. However, for special textural effects, you can coat its white surface, in whole or in part, with white casein or acrylic paint. Illustration board comes in rough, medium, and smooth surfaces, and in single and double thicknesses.

MAT BOARD Another way of getting a tinted ground is to use mat boards. They come in various colors and in "pebbled" or smooth surfaces. All you have to do is to select the color that suits the work you're about to do. I've used a blue mat board for Project 12, and a brown one for Project 17, because these boards facilitated the development of the color schemes in each of the paintings.

STRETCHED CANVAS AND CANVAS BOARD Going along with my lazy disposition, I've never primed or stretched a canvas; I prefer to get them already prepared. I'd consider doing it if I was inclined to use vast areas, like the 8′ x 20′ some artists need. Since I hardly ever do a painting larger than 40″, I feel I can indulge myself and get ready-made supports. However, because of the type of water-based media I use, I prefer the rigid surface of canvas board. I know then that heavy impasto will not crack or chip off as I'm afraid it would on the resilient surface of stretched canvas.

BRUSHES I use bristle flats when painting large areas with thick pigment because their longer stock holds more paint than the brights, which I

use to smooth out areas or to lift paint from a section that's become overloaded. Bristle flats are excellent for scumbling and for the first thin underpainting.

However, the square and the round-pointed sable brushes are the workhorses of the magic realist technique. I suggest that you acquire as many as possible, beginning with #3, #5, and #7 pointed sables and a #20 square sable. Later you can add the smaller and the larger sable brushes.

Do try to use the nylon brushes when working in acrylic. Grumbacher puts out the Hyplar line in flats and round-pointed brushes. These nylon brushes are compatible with the chemistry of acrylic paints and resist the harm that this medium allegedly inflicts on bristle and especially sable brushes. I've been using my watercolor brushes when working with acrylic and, so far, I've noticed no damage. But I take care to rinse my brushes constantly while painting and give them a thorough washing with soap and water when I'm finished for the day.

KNIVES Palette and painting knives are made in a great variety of shapes and sizes, and in various degrees of flexibility. As their name implies, they can be used for scraping as well as for applying paint. The blade length of these knives can range from 1″ to 4″ from the tip of the blade to the place where the neck begins. I've used a 2″ trowel-shaped blade for the work in this book. If you prefer to paint in larger dimensions, of course, you'd use a larger knife.

UNORTHODOX TOOLS How ingenious it was of the first painter who picked up whatever was at hand to create effects that the brush itself would accomplish only grudgingly and with great coaxing. If your brush can't do what you desire, put it aside and pick up a razor blade, a sponge, a piece of crumpled paper, or even use your thumb! I find the razor blade indispensable for scraping an impasto, after it's been glazed, to depict the rough textures of walls and rocks. I sometimes further "rough up" wet impasto by tapping it with crumpled paper—from thin tissue to the thick brown paper of supermarket bags. I also use the corner of the razor blade to make incisions in the paint to simulate light blades of grass against a dark mass. I can simulate the texture of weathered wood by running the corner of my razor blade along the length of the boards. Then, even if the board is vertical, the incisions are still along the length.

PALETTES The wood palette was popular with oil painters because its color approximated the brown undertones that used to be the initial stages of work done in this medium. The oil paint colors that followed were easier to mix and adjust on a surface that was similar in color to the

canvas's imprimatura. Today, artists use white palettes—whether they're wood, plastic, china, enamel, or paper—because their work, as a rule, begins on a white ground.

My favorite palettes, because of the water-based media I use, are white enameled butcher's trays, in various sizes, and the slant-and-well palettes in lengths of 3-well, 5-well, and 8-well according to the number of colors I intend to use. I place my slant-and-well palette on a butcher's tray, fill the wells with color, and then mix tints and shades with water on the butcher's tray. When working with egg tempera, I also use nests of china bowls or cups that fit snugly, one on top of the other, to keep the egg tempera colors in each cup moist, even overnight. I have sets of these china, and plastic, cups in 2″ and 3″ diameters. Other containers can serve just as well for egg tempera, as long as they're tightly sealed (any plastic wrapping material will do) so that the point stays moist.

EASELS AND TABORETS

Studio and sketching easels are such personal acquisitions that each artist must select the type that is most suitable to his temperament, approach to painting, and even physical conformation. Some artists never sit to work, while others never stand. Some paint on an almost flat angle using a drawing table, while others prefer a vertical plane. So I leave it up to you to choose an easel or a drawing table that fits your personal requirements.

I use a 26″ x 20″ drawing board when sketching outdoors. I also have a portable studio easel indoors that I can fold up and put out of the way, but I do most of my work on a 40″ x 30″ drawing table. A taboret is also a piece of equipment that should be chosen according to your personal needs. If you're beginning to paint, a small one should be adequate. But if you've accumulated tons of paraphernalia, as I have, then a large one would be the wise choice.

PAINTING TECHNIQUES

As I've mentioned before, water-based media (egg tempera, gouache, casein, and acrylic) lend themselves particularly well to the "magic realist" approach. These media require careful handling and precise brushwork. They allow the artist to work carefully to build up many layers of paint.

I forget who the chap was that said, "I paint skin the way the Lord created it—in layers." By this he meant that his first layer of paint might be gray-green, blue-gray, or even just gray. When this layer was dry, he would paint on thin layers of red, then with yellow until he achieved flesh-colored tones. As a rule, an underpainting is light in value. Subsequent layers of paint are very thin and transparent. Each layer contributes a tone or tint until the desired hue is finally reached. This kind of build-up can produce marvelous effects. Such effects, combined with a precise rendering of detail characterize the

paintings you'll see in the following demonstrations. But first, let's discuss some of the basic methods for handling the four media and what kind of effects these methods produce.

PAINTING WITH OPAQUE WATERCOLOR

With this medium I use the slant-and-well palette on the butcher's tray but I don't wipe it, wash it, or scrape it off as I do when working in acrylic or egg tempera. With a wet brush I can pick up the paint mixtures that have dried on the palette. With opaque watercolor, I can also get lively grays by rubbing a brush charged with white over the various dried colors. At the end of the day I soak the tray in the sink and rinse my brushes thoroughly. Then I add a few drops of water to the color in the wells of the palette and cover the palette with another slant-and-well palette to prevent evaporation, just as I do when using acrylic paints.

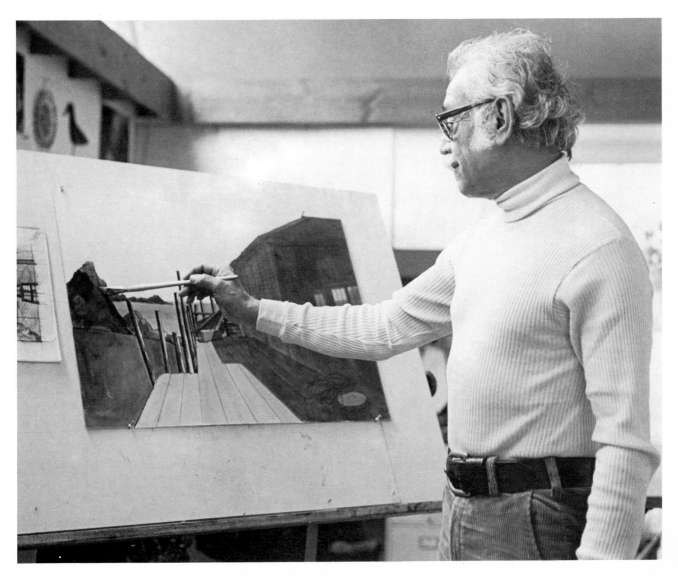

Beginning to Paint. Here I'm laying in the first thin washes with my trusty #20 flat sable brush. Notice that I've pinned my first sketch next to my painting for easy reference.

PAINTING WITH ACRYLIC There are nylon brushes which are expressly made for use with acrylic because it's rather harsh on the regular watercolor brushes. However, I could never get used to the hard, irresponsive stock of nylon brushes. I use sable brushes with acrylic but I take the utmost care to rinse them before I lay them aside while painting. Of course, I wash them thoroughly in warm water and Ivory soap when I'm through for the day.

I use only water as a medium for thinning my acrylic paint. Again, I use a slant-and-well palette and a butcher's tray when I paint with acrylic. As I work I continue adding a few drops of water to keep my paint moist. When I'm through for the day, I soak my tray in the sink and cover my palette with another slant-and-well palette that fits over it snugly. Sometimes with acrylic paints I use a paper palette that I can strip away to give me a clean surface.

PAINTING WITH EGG TEMPERA I use regular watercolor brushes with egg tempera. When beginning to paint I first dip my brush into the water jar and unload its content on my butcher's tray; then I dip into the color, all the way to the bottom of the dish. I take my paint-filled brush and dip it in the water on the tray, working it to a point, or "fanning" it, depending on my needs. This procedure gives me just the right paint consistency to begin my first layer of color. When I break for lunch I cover the dishes filled with egg tempera so they won't dry up. On my return, if I notice that some of the colors are drying, I simply take a sponge and add a few drops of water and stir them again.

When the day's painting session is over, I add water to all the egg tempera colors and cover them. In the morning they'll be moist and all I'll have to do is to stir them again. As the egg tempera on the butcher's tray gets dry, I scrape it off with a razor blade. If the paint rolls off into compact tubular strips, I know there's still enough egg yolk binder in my paint. If the paint scrapes off into dust, then I add more of the egg yolk (which I've kept refrigerated) to the paint in the dishes.

When a color gets used up, I take a *clean* dish for the new mixture. I put the used dish in a water jar to soak. I wash it thoroughly later with a cleanser and hot water. If I don't take these precautions, chances are that the egg used in the tempera paint will spoil before the day's over and smell up the studio.

PAINTING WITH CASEIN When using casein I squeeze out little dabs along the edge of the butcher's tray. Then I make a little "well" in the middle of each mound with my brush and fill these "wells" with water to keep these paint mounds moist. You can use both bristle and sable brushes with casein. However, wash them constantly with soap and water—while painting—as you'll see me do in Project 22.

Now let's look at some specific painting techniques that you can employ with all the various painting media we've been talking about. Unless I specifically mention otherwise (as I do with impasto, for example) all the methods of applying paint that follow can be used with all four water-based media.

WASHES Washes are diluted applications of paint. You can use them to render a flat tone, one that's all one value or hue. You can also create graded washes—washes that ranges from dark to light or light to dark. A graded wash is an excellent way to render a sky, for example, which is darker as you get further from the horizon line. (See Figure 1.)

DRYBRUSH Drybrush is a technique which involves using a brush that's almost "dry" or devoid of paint. When you drag such a brush across a support, it leaves paint in some places and not others, producing "gaps" through which the paper or other surface shows through. Since drybrush plays such an important role in the magic realist approach, let's find out what must be done to obtain the different effects that drybrush can produce.

The first thing to remember when using drybrush is that your paint—any kind of paint—must have a thinner consistency than the paint you would use for wet-brush painting. Here's where many students get into trouble. They do everything right except that they fail to thin their paint down until it's mostly water.

EMPTYING YOUR BRUSH The first step in preparing your pointed watercolor brush for drybrush painting is to "empty" it. This simply means that after dipping your brush into any type of paint, you drag the entire stock (or body) of the brush (Figure 2) from tip to heel over a piece of scrap paper to discharge most of the pigment (Figure 3). When you've emptied your

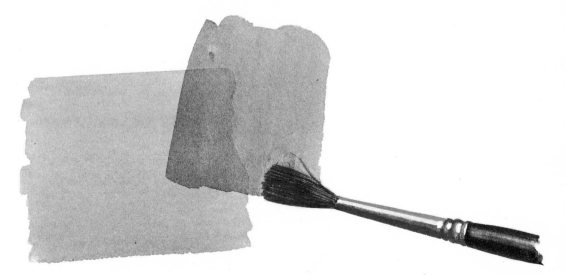

Figure 1. Washes are thin, transparent applications of paint. They provide an excellent means for beginning a painting because you can quickly cover large areas with them.

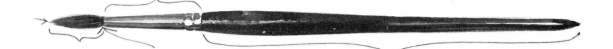

Figure 2. The pointed sable watercolor brush is the workhorse of all the tools used with the magic realist media.

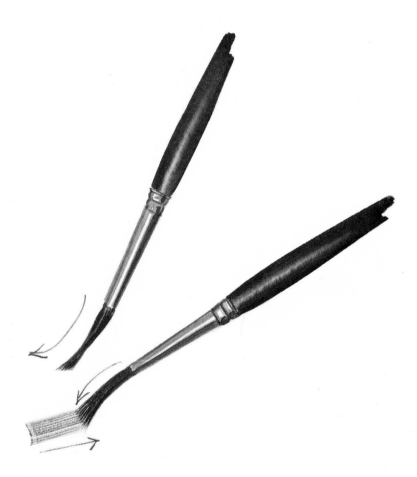

Figure 3. The first step in the drybrush technique is to "empty" your brush of most of its paint—to make it dry.

Figure 4. Emptying your brush in the manner shown in Figure 3 leaves its point "fan-shaped." By turning your brush as shown, you can make crisp strokes by sweeping the brush from left to right.

brush, you'll notice that its pointed tip is now "fan-shaped" and slightly at an angle because of the pressure exerted on its entire stock (Figure 4).

To get firmer and crisper strokes, turn your brush so that the convex side is to your left—if you're right handed—and make sweeping strokes from left to right. For vertical strokes, turn the convex side to the top of the board or paper and pull the strokes toward you. If, as you're working, the brush begins to regain its original pointed shape, press it down again on the scrap paper to regain the "fan." You may have to recharge it.

DRYBRUSH EFFECTS There are certain effects that don't require the broad side of the "fan," but its edge. For example, to get textured effects, you can use the edge of your dry brush as in Figure 5. The angle of the brush for this stroke is almost perpendicular to the surface of the paper. Another stroke which achieves good textural effects is shown in Figure 6. To get this effect, empty the brush until it's barely charged with paint, and hold it almost flat against the paper. Then drag the brush down quickly with its entire stock rubbing the painting surface.

SPONGE AND DRYBRUSH Textures can also be achieved with a sponge and drybrush. So, from now on, don't throw away your worn-out synthetic or natural sponges. They're invaluable for getting effects that would entail laborious rendering if done in the conventional manner.

For example, to get a simple textural effect, all you have to do is press a piece of sponge into a puddle of thinned paint. Then, tap the sponge on the paper as in Figure 7. To see the effects that different sponges will produce, squeeze some black paint into a butcher's tray; dilute the paint with water and begin tapping away with your sponge on a piece of scrap paper. Can you imagine how long a brush would take to render textures like these? Get different natural and synthetic sponges—from the finely porous to the big and coarse—and use them according to the requirements of a particular passage.

WET-IN-WET EFFECTS You probably already know everything about wet-in-wet painting; that is, using a fully charged brush on a damp surface. Just to show you the dramatic contrast of the wet-in-wet and drybrush techniques alongside each other, do the following as an exercise. First, make a few strokes with a fully charged wet brush on damp paper as in Figure 8. Notice how one tone spreads into the other, depending on the degree of wetness of the paper and the amount of paint on your brush. You can use one brush to create these tones, rinsing it clean each time you dip into a new value, or you can use a separate brush for each tone. You can use black and white only and mix the gray tones from them as you require, or you can use the Gamma grays (by

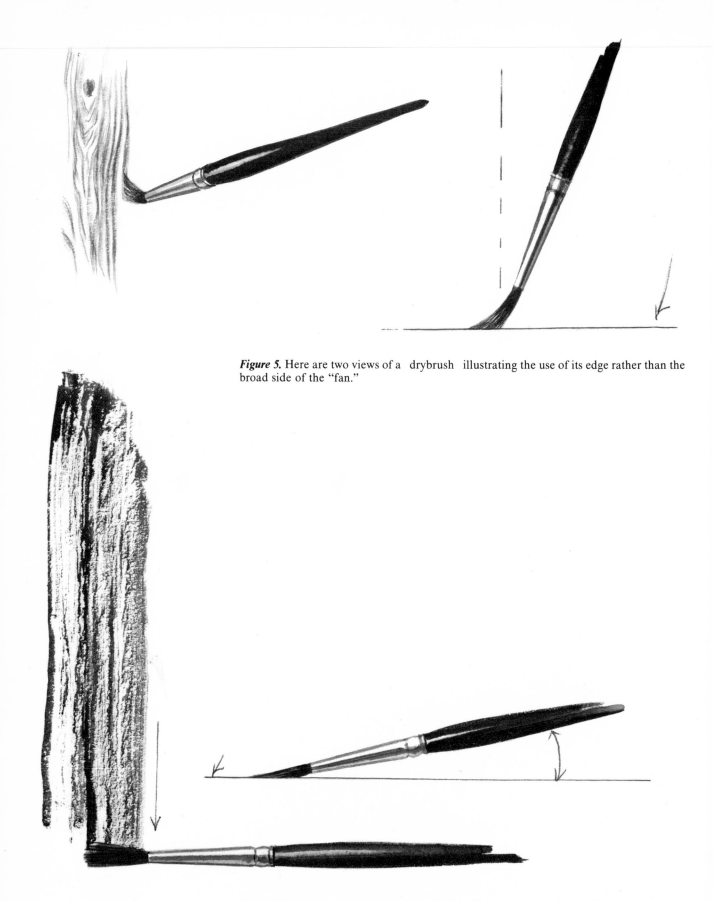

Figure 5. Here are two views of a drybrush illustrating the use of its edge rather than the broad side of the "fan."

Figure 6. Another way to manipulate a drybrush is shown here. By holding your brush almost flat against a surface and dragging with its entire stock you can produce the texture shown at the left.

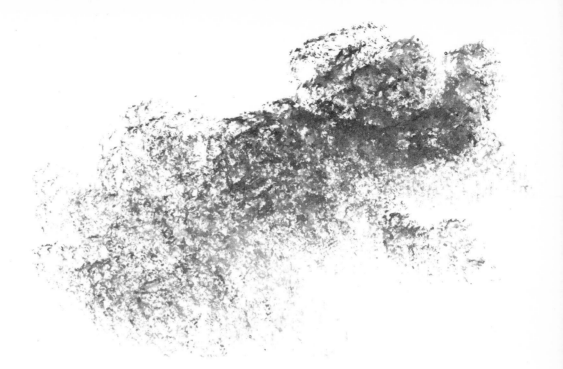

Figure 7. You can produce the texture shown here by tapping your painting surface lightly with a paint-filled piece of sponge.

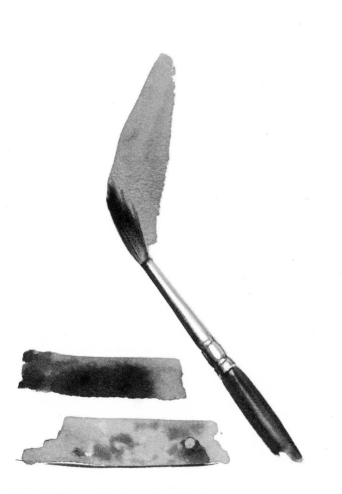

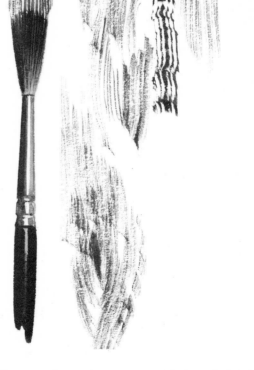

Figure 8. Using a fully charged wet brush on damp paper, you can create the wet-in-wet values you see here.

Figure 9. Compare the wet-in-wet tones with these drybrush strokes. You can use these two effects singly and in combination.

Grumbacher) that come already prepared in tubes or in jars.

Now empty your brush (as you did in the beginning, Figure 3) and make a few drybrush strokes with it as in Figure 9. A totally different effect, isn't it? It's this combination of techniques—wet-in-wet, dry-brush, and sponge—that will come into play most often in the paintings demonstrated in the projects to come.

IMPASTO By applying paint thickly (without using a thinner) to a surface, you can create impasto. In Figure 10 you see a trowel-shaped painting knife. I use such a knife to apply, pat, and rub the paint—with the flat of its blade—to create impasto. Impasto lets you create rough textures that can suggest plaster walls and rocks. When an impasto dries, you can glaze it with whatever color you require. If needed, you can scrape it with a razor blade to intensify protuberances. Don't lay aside your painting knife without washing it, because the paint will harden.

I've demonstrated the application of impasto with a painting knife (Figure 10) but you can also do it with a flat bristle brush (Figure 11). The effect is altogether different and it can be used to suggest the bark of trees, rough ground textures, or weathered wood. You can glaze such an impasto and scrape it with a razor blade to heighten the desired effect.

GLAZING Glazing means to apply thin films of paint over an already dry, painted area to deepen a value, to reinforce color, or conversely, to subdue color. Whatever your medium, take care that your under-painting is completely dry before you attempt to glaze it. Always use a soft brush. A #20 square sable brush (Figure 12) is my favorite brush for applying glazes. If your first glaze turns out to be too light, you can apply another on top of it, after the first one has dried.

USING A RAZOR BLADE When you apply a glaze to a white impasto, instead of emphasizing texture, it often obscures the configurations of the paint underneath. When this happens, let your glaze dry and then scrape it with a razor blade (Figure 13). This will partly remove the glaze and reveal the rough textures of the thick impasto that you previously applied with your painting knife. If the texture is brought out too strongly, it can, of course, be glazed again to subdue it.

Here's another use for the razor blade. Instead of the entire blade, (Figure 13) use only the corner to make incisions over a tone (Figure 14). Such an effect can suggest peeling paint and light leaves of grass. It can also be used to depict light branches and twigs against dark foliage, and any other thin and delicate delineation on a dark ground.

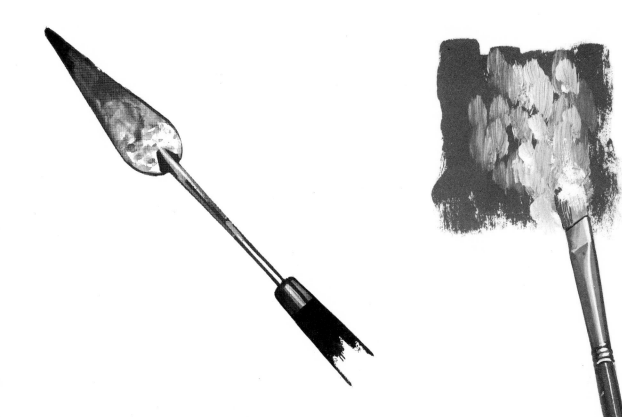

Figure 10. With a painting knife such as this one, you can apply acrylic or casein paint to create impasto effects. By rubbing and patting the paint with your knife, you can create even rougher textures.

Figure 11. You can also create impasto by applying thick paint with a flat brush.

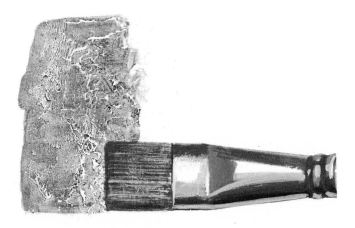

Figure 12. Over a white impasto you can glaze a darker, but transparent, tone. By diluting your paint with more water, you make a glaze thinner and more transparent.

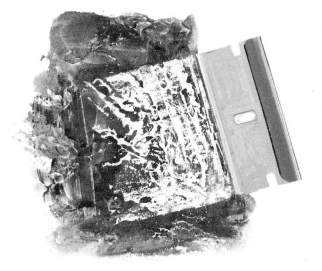

Figure 13. Sometimes a glaze, like the one in Figure 12, can subdue the textures of an impasto. When this happens, you can scrape off some of the glaze with a razor blade to bring the texture back.

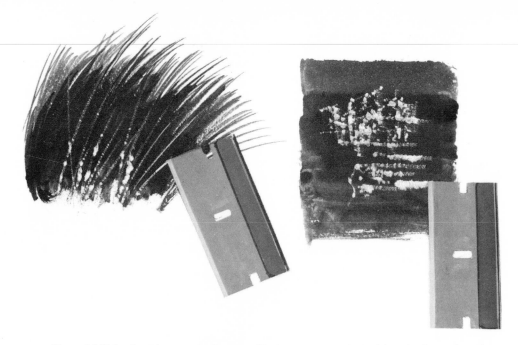

Figure 14. Using just the corner of a razor blade, you can make incisions in dry underpainting to create blades of grass or any other delicate delineation on a dark ground.

Figure 15. Using a minimum of paint, rub the entire side of the stock of your watercolor brush to produce this effect which I call a scumble.

Figure 16. By holding your brush perpendicular to your painting surface and tapping it vigorously, you can produce the effect shown here which I call stipple.

SCUMBLING AND STIPPLING Remember that a brush doesn't just daub paint. It can produce amazing effects depending on how you manipulate it. To scumble, load your brush with a minimum of paint and then rub with the entire side of its stock, holding the handle of your brush under the palm so that it's almost parallel to the painting surface. This technique allows you to simulate marvelous rough textures (Figure 15). If still rougher textures are required, try stippling. Hold your brush perpendicular to the plane of the support and tap it vigorously. Don't be timid. Really stipple and bang away; it won't damage the brush (Figure 16).

One more very important thing. Before you begin painting, I want to stress that I've simply described the mechanics of several basic techniques and other initial preparations. These should be subordinated and modified to suit the character of the particular object you want to depict, whether it's an old barrel, a rock, the siding of a barn, or the planking on a dock.

Squaring Off

In the course of these projects you'll see me use the techniques I've just discussed in the previous chapter. Yet, no matter how many different techniques I may use in any one painting, my "magic realist" approach has a standard plan of action. I usually begin with a color sketch of my subject, which is often made on-the-spot and therefore relatively small. I generally use opaque watercolor for this preliminary sketch.

Next, using the "squaring off" procedure that I'll describe further on, I make an enlarged pencil drawing from the color sketch. Then I trace this enlarged drawing onto whatever surface I'll be using for my final painting. Once those three preliminary steps are finished, I begin my painting in earnest. In the following projects I may not always use all three, but they form the basis for my "magic realist" approach.

Here's my squaring off method as I used it in the demonstration painting. I tape a sheet of tracing paper over the sketch so that it won't be marred. First, with an office pencil and a ruler I draw a horizontal line along the top of the barrel and another one touching the bottom. Then, I draw a vertical line touching the left side and another line touching the right edge. I now have a rectangle enclosing my barrel. Then I measure the halfway points on both verticals and horizontals and subdivide the area between into a grid of four smaller rectangles. I further subdivide these into a still smaller grid. You could subdivide this grid even smaller, depending on the complexity of your subject. I draw in two diagonals across the top four rectangles because most of the detail is there and I need more lines to guide me.

For this project you'll use #3 and a #7 pointed red sable brushes. Such brushes are made by Winsor & Newton, Grumbacher, or Delta, and they're all excellent. For enlarging your sketch, you'll need 11″ x 14″ and 19″ x 24″ tracing paper pads. For the final opaque watercolor painting, you'll use a 16″ x 20″ piece of illustration board, medium texture, any brand you wish. Be sure the surface paper on the board has enough "tooth" to take opaque properly. In addition to brushes, you'll use natural and synthetic sponges. A butcher's tray or a large white china plate, a water jar, and rags—to wipe the brushes after rinsing—are all necessary.

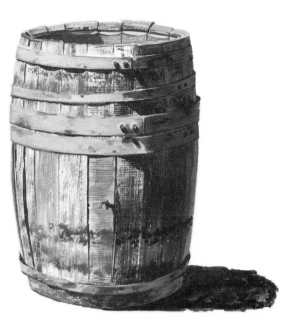

Step 1. *I begin this demonstration with an on-the-spot sketch. I use transparent washes of opaque watercolor on the staves, and then thicker applications on the hoops. Of course, I want my finished painting, which I'll work on back in my studio, to be larger. Since students don't have enlarging devices, like a projector or a pantograph, I suggest the following method.*

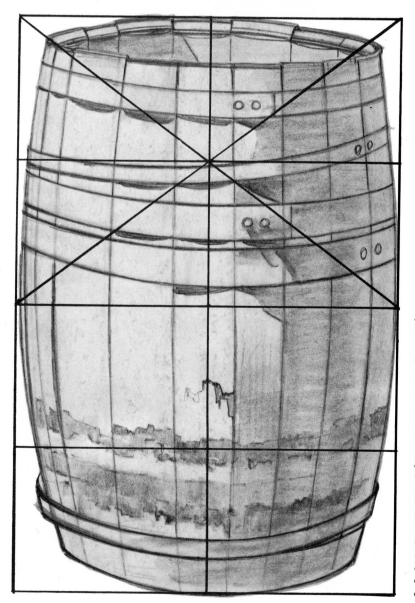

Step 2. *To enlarge the original sketch from 5″ to 10″ high, I simply double the size of the grid that I drew on the overlay onto another piece of visualizing paper. Then I go over the grid lines with a felt nib pen to make them really black and bold. Since I want to do my enlarged drawing without the lines of the grid disfiguring it, I tape a piece of tracing paper over the larger grid. The tracing paper allows me to see through to the grid underneath. With an office pencil I copy the linear structure of the sketch, using the grid to help me achieve proportion. When the enlargement is finished, I take another sheet of tracing paper and blacken one side of it with the #314 draughting pencil. I slip the blackened sheet between the enlarged drawing and a 16″ x 20″ piece of illustration board and go over the lines of the enlarged drawing to transfer it onto the board.*

Step 3. *Here's the drawing that I trace onto the 16″ x 20″ board after enlarging it from my original sketch. The background behind the barrel is a corner of my neighbor's shed and the beautiful broken concrete is on the floor of his garage. When working from different sources as I did here, make sure to keep one consistent light angle. In this case, I did the barrel at Cape Cod, and it happened to be lit from the upper left (check Step 1). Since I wanted a background to set off my motif, I had to check carefully that the background's lighting would be the same. Actually the shed was lit from the right, which threw a cast shadow to the left of the corner. It goes without saying that there can't be two sources of light outdoors, so I "forced" the shadow on the shed to set off toward the right to conform with the direction of the shadow on the barrel.*

Step 4. *Now I start the actual opaque watercolor painting by laying in the background with thin washes (black pigment much diluted with water). I use the #7 watercolor brush and work these washes slightly into the contour of the barrel. When the washes dry, I "fan" the #3 brush and begin the articulation of the texture on the wall and on the barrel with drybrush, still using very thin paint. Notice I've taken the texture of the wood staves slightly into the hoops, because I know I can trim back the hoops with thicker pigment. These hoops will be done last but to demonstrate, I've defined portions of the first and second top hoops and part of the top edge of the barrel. In order to carry the entire picture forward, I begin the foreground by tapping with a piece of paint-filled sponge. I use a piece of natural, finely porous sponge soaked in rather thick paint, as well as a piece of coarse synthetic sponge to create a variety of texture.*

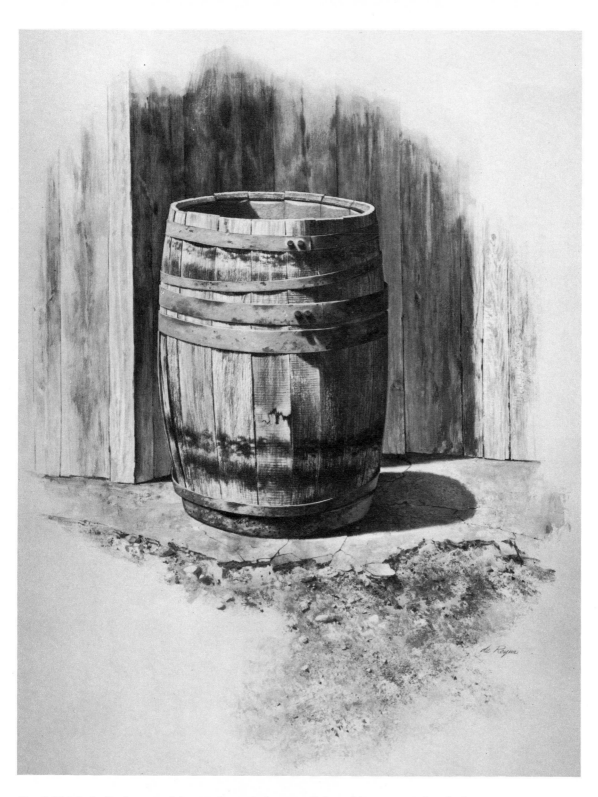

Step 5. *This is the final stage and the most fun to do, because all the problems are usually solved by this point. From here on it's a matter of pulling the picture together by sharpening or softening an edge, deepening or lightening a tone, and bringing out or subduing a detail. Note that I've kept the texture of the wall subdued and soft in comparison to the minute and sharp detail on the barrel. For the concrete, I use thick paint which I scrub on with the side of the brush. I smooth out some parts of the wall with an empty dampened brush. The cracks on the concrete are done with the point of the #3 brush in thin, dark pigment. Then, over the sponged surface on the foreground, I define carefully the rocks and pebbles with the #3 brush. I take care that the lighting remains consistent throughout, even in these small details. Finally I render the top edge of the barrel, refine the details on the hoops, and finish the rust stains on the barrel.*

PROJECT 2

Color Schemes with Opaque Watercolor

There are times when your preliminary pencil drawing (usually Step 1 or 2 in my demonstrations) is so exciting that you want to keep it intact and not lose it by painting color over it. On these occasions you can try out many color schemes by using acetate. Acetate is clear and allows you to follow and fill in the areas in your pencil sketch with color without actually disturbing your drawing. Simply place a sheet of acetate over your pencil drawing and paint your colors on it. After you find the color scheme that best suits your subject, you can wash off the paint from the acetate sheets and use them over again. In this way you don't have to make a separate sketch in pencil to use as a referenae for detail and a separate sketch in opaque watercolor to use as a reference for color as you did in Project 1.

The paper or board chosen for a painting has a great influence on its final appearance. For the final painting in this demonstration I use a 20″ x 15″ double thickness, cold-pressed #114 Crescent brand illustration board. It has a surface of 100% rag Strathmore watercolor paper. In addition, for this project you'll need a pad of 16″ x 20″ tracing paper, and a Wet Media acetate pad size 20″ x 24″. It's also available in smaller sizes, but get the biggest, and then cut the acetate sheets to any size you require. You'll need a #2 standard "office" pencil and a 5H pencil. You'll use the following opaque watercolor palette: white, ivory black, raw umber, yellow ochre, flame red, and Winsor blue, as well as #3, #5, and #7 watercolor brushes and a #20 flat sable.

Step 1. What excited me about this boat was the abstract "explosion" of lines created by its masts and the framework of its cradle. I was an inordinately long distance from home, so I recorded in this drawing the precise details that I knew I would need later when painting. I indicated only the edge of the grass because I had studies of grass back home that I could refer to. For this drawing I used a #2 office pencil and on the #524 Aquabee pad of tracing paper.

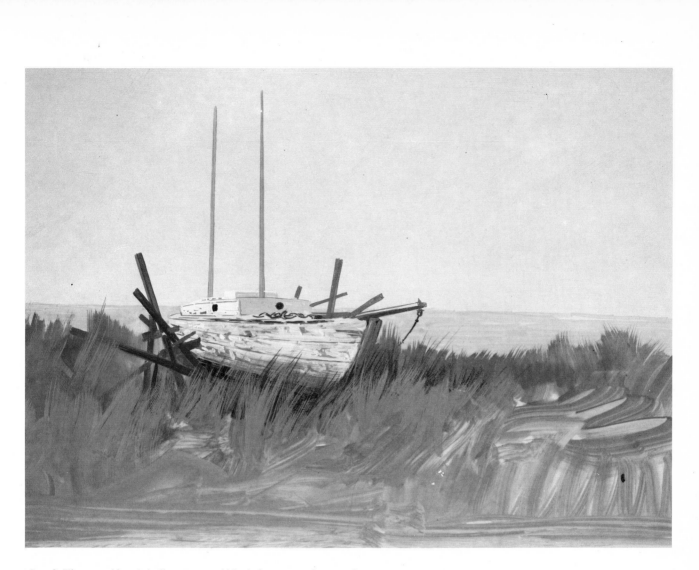

Step 2. *The actual boat's hull was painted black, but to me a boat is white, or was at one time, so that's the way I paint my boat. To keep my original drawing intact, I use the "acetate approach," mentioned earlier. That allows me to try out as many tonal and color schemes as I wish. The color scheme I select consists of a mixture of white and Winsor blue, tempered with yellow ochre, which I use for the sky. Yellow ochre, raw umber, black, and white I mix for the grass, and yellow ochre, raw umber, Winsor blue, black, and white for the boat's timbers. Its hull is mostly white with mixtures of umber, white, and black, and also blue, white, and black for the bare wood spots, depending on whether I wanted them cool like the former combination, or warm like the latter.*

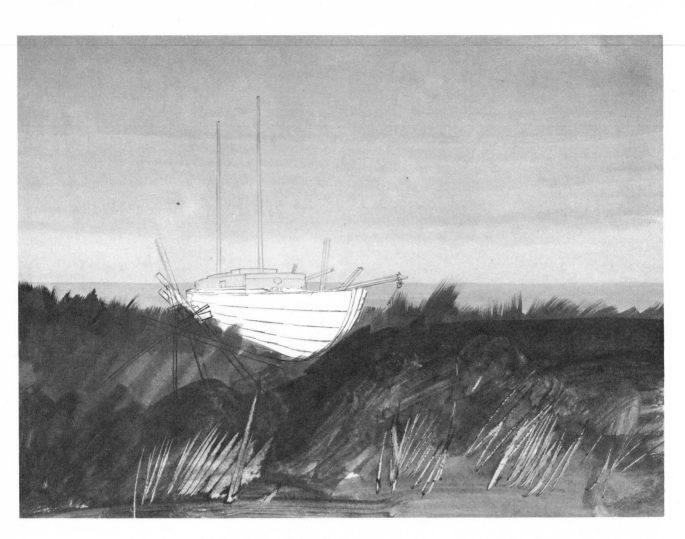

Step 3. *Here I trace the drawing onto Crescent illustration board. Before I trace it, I place another sheet of 16″ x 20″ tissue paper over the drawing so that I won't dig into the drawing itself with my hard 5H pencil. After tracing, I turn my illustration board upside down and start at the horizon line to lay in a wash composed of Winsor blue with some yellow ochre. Using horizontal strokes from edge to edge, I add more blue and ochre to darken the tone as I work my way down to the top edge of the sky. Notice that the drawing of the top of the boat and its masts still show through because my paint is thin. Then, with the board right side up, I paint the water and broadly lay in the grass, adding more yellow ochre to achieve a green. If any important details get lost at this stage, when the paint dries I place my original drawing on top and retrace them.*

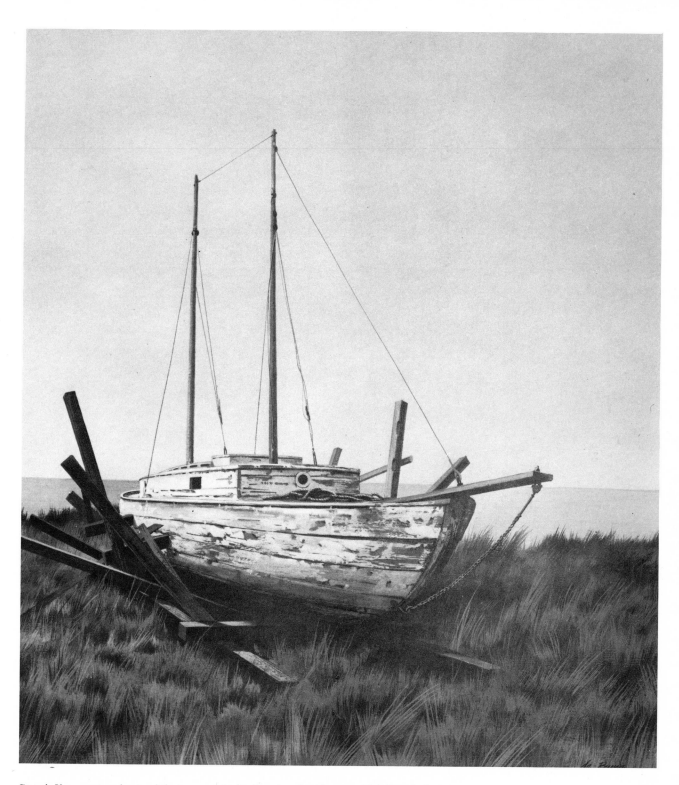

Step 4. *You must understand that a great deal takes place in this step which I can't show you here. There's adjustment of values, modeling of forms, refining of edges, and delineation of detail. A good procedure to follow is to first create the proper lights and shadows on the major forms. I paint the bulk of the boat's hull, its cubic cabin and timbers, and its cylindrical masts, using white and a combination of black, raw umber, and Winsor blue. When an object overlaps another, I do the one behind first. The grass consists mostly of yellow ochre and Winsor blue mixed in proportion to produce a cool or warm green as needed. For shadows in the grass I use a mixture of Winsor blue, black, and raw umber. I do the grass, whether short or tall, as it grows—with upward sweeps of my watercolor brush. I've changed the picture from a horizontal composition to a vertical one to focus more attention on the boat, and create more of a "close-up" of pathetic decay.*

Opaque Watercolor Washes

In this project you'll get some more practice in creating washes with opaque watercolor. Washes, as you know, are thin, watery mixtures of paint that allow you to cover large areas quickly and, therefore, provide an excellent way to begin a painting. You can use washes to create your flat underpainting. On top of this underpainting, you'll gradually build up texture and detail with layers of thicker paint. This process is, of course, the essence of my tempera technique.

Keep in mind that this procedure just mentioned is perfectly applicable to the other water based media, which I'll be demonstrating shortly, However, in these first projects I thought it best to begin with opaque watercolor, because it's easier to manipulate and more convenient to set up for brief periods of time. In this project, you'll also get practice in manipulating lights on a still life to bring out the various forms and make the shadow pattern more interesting.

You'll need the following surfaces for this demonstration: a pad of tracing paper (I use the #524 Aquabee pad), and a 33″ x 30″ piece of rough surface illustration board for the final opaque watercolor painting. For this demonstration I use Superior brand illustration board. In addition you'll need #3, #5, and #7 watercolor brushes, the #20 flat sable, as well as India ink and Gillott's #303 pen.

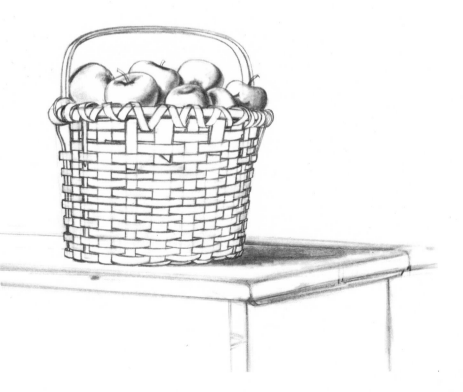

Step 1. When I saw these apples on the kitchen table, I found their green color so appealing that I decided to do a painting. First, I solved the drawing problems—construction, proportion, tonal values—as you see in the drawing here. The light is coming from the upper left. Notice that I've begun to model the apples, but I leave out the shading on the basket because I don't want to obscure any of its linear detail. I use an office pencil and the #524 tracing pad. With so many marvelous drawing papers about, you may well ask why I do most of my drawings on tracing paper. Remember these are only working drawings that have specific mission in the development of a painting; they're not ends in themselves. This drawing measures 13″ x 11″.

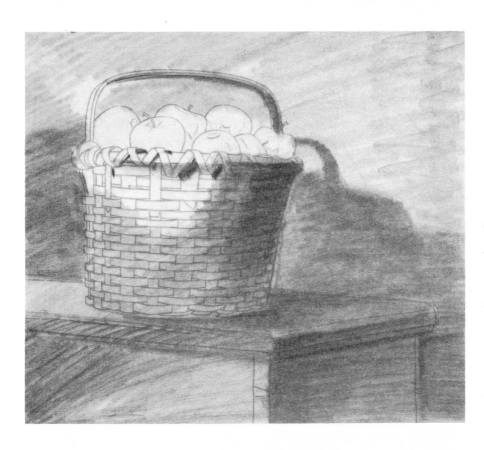

Step 2. Here, I place my first drawing with its linear detail under another piece of tracing paper. Using my draughting pencil, I try several shadow patterns, all with the light coming from the upper left, but I don't like any of them. So I switch from natural light to artificial light because I can completely control the latter. Originally, with half the cylindrical form of the basket in the light, the weaving was a bit too persistent and detracted from the apples which I wanted to emphasize. So now I set up a piece of cardboard that will cast a shadow on the left side of the basket as well. Now I have it. With the basket mostly in shadow, attention can center on the apples.

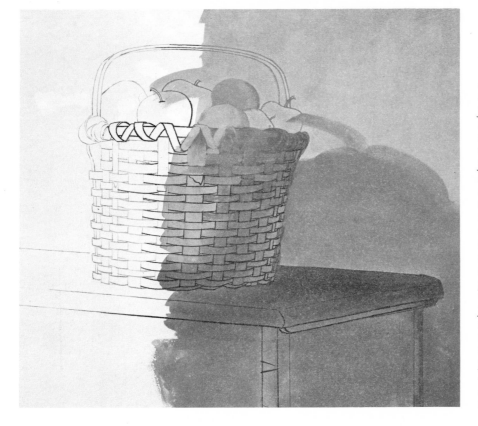

Step 3. I could have shown you separately the traced line drawing, the reinforcing of the line drawing, with India ink, and the first thin washes that allow the inked lines to show through, and finally the beginning of the modeling of forms and rendering of texture. But these steps shown individually would have gobbled up a lot of pages. So I show you pieces of all these various steps here in one picture. Let me recap the procedures involved that led up to this stage. After tracing my line drawing onto the illustration board, I go over it with India ink with the #303 pen. When the ink dries I float on thin washes with my #20 flat sable. The first washes consist of a diluted mixture of French green, black, and white. For the basket I use yellow ochre, burnt umber, cadmium red light. For the apples the colors are Indian yellow, French green, and burnt umber. Then I'm ready to begin modeling as you see on the topmost apple.

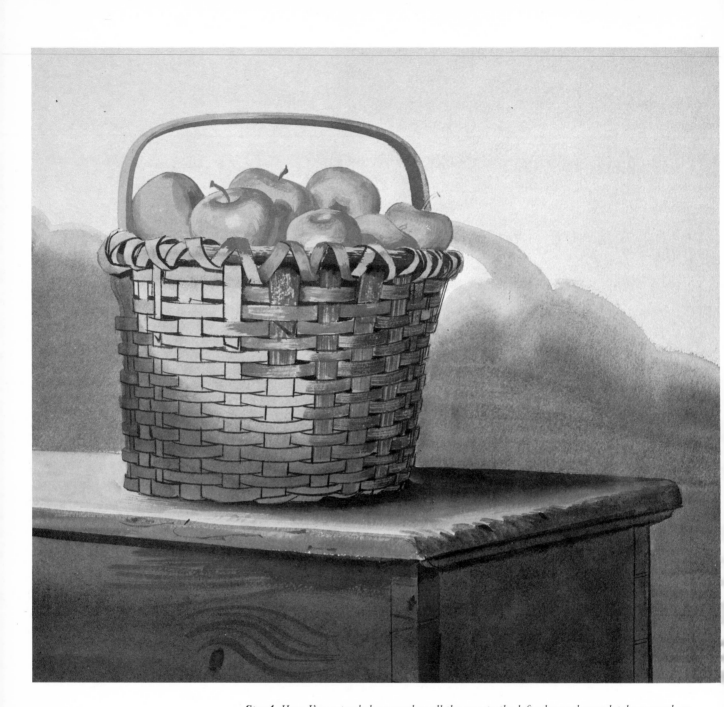

Step 4. *Here I've extended my washes all the way to the left edge and completely covered my pen-and-ink line. However, as you see, it still shows clearly through the thin washes of color. Remember to keep your cake opaque colors wet by periodically squeezing a sponge over them. Besides the colors in the Marabu box, I'm using a 2 oz. jar of Artone white. I've started to model the apples, the basket, and the chest with thin paint. I just want to establish their form by decisively separating their light and shadow areas. Later I'll add details, textures, and whatever refinements I need. I've also lightened the background because I need contrast to bring out the apples, which are to be the center of interest.*

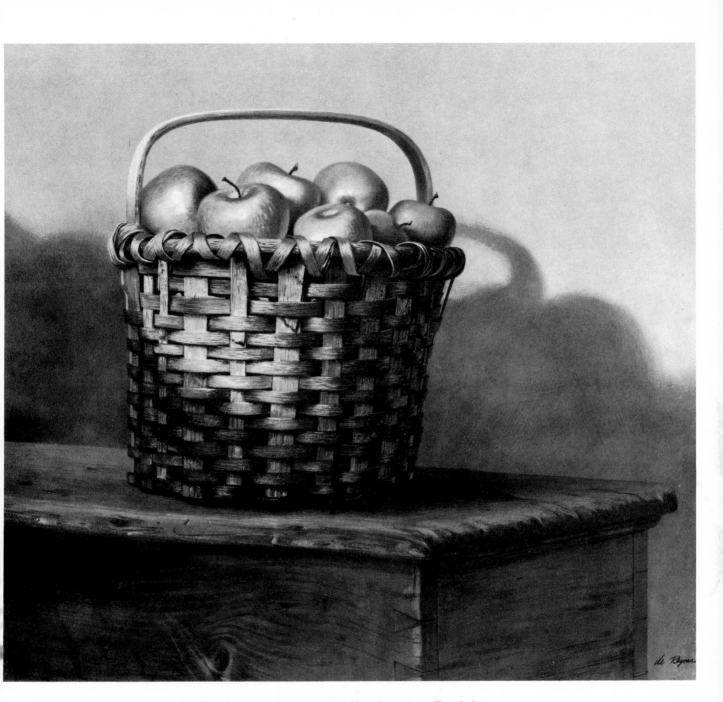

Step 5. *The last step consists of pulling the entire picture together. If a value comes off too light, I work a darker tone over it with drybrush. If the value is too cool, I warm it up with yellows. If it's too warm, I try green or umber tempered with white or black or both. I model the apples wet-in-wet and refine edges with a drybrush and very thin pigment. Then I proceed to the minute detail of the weave of the basket and the texture of the old chest. I work smoothly and strive to show the surface qualities and values of a particular area rather than clever brushwork. Just when I think the painting is finished, I notice that the apples are a trifle too cool. So, with the #7 brush I float a thin layer of yellow ochre over each apple very lightly so that I don't disturb their definition. This yellow dims the highlights a little, so I go over them again with white.*

Drybrush Over a Wash

In this demonstration I apply thin washes of opaque watercolor over the entire surface of my illustration board. Then I use drybrush on top of these washes to create texture. Again, you'll see me use the squaring-off method of enlarging. The opaque watercolor sketch that I begin the demonstration with is 6½″ x 9″, and the final opaque watercolor painting measures 12″ x 16″. I enlarge my color sketch to a pencil drawing so that I can refine structure and "nail" down the fundamentals of composition.

For this project you'll need an 11″ x 14″ watercolor pad, a 15″ x 20″ pad of tracing paper, a 15″ x 20″ piece of illustration board (rough surface, single thickness), as well as #3, #5, and #7 pointed sable watercolor brushes, and your old faithful #20 flat sable. Strictly speaking, this last brush is a "bright," but I shall continue to call it "flat" to differentiate it from the round pointed sable brushes. You'll need the following opaque watercolor palette: ivory black, white, raw umber, yellow ochre, and flame red.

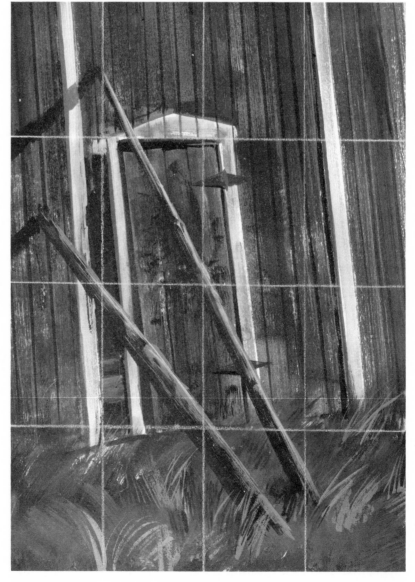

Step 1. The 11″ x 14″ Bristol paper pad is just great for outdoor sketching, and I try to always have one in the car, along with the box of Marabu watercolors. I found this barn in upstate Connecticut, and I bless the man who placed those poles on the door. They make such a beautiful linear arrangement against the white trim of the building. I start by laying in the entire wall with a wash, using my #20 flat sable. For the wash I use cadmium red light and black and leave the white trim intact. While the wash dries, I indicate the grass with the #5 and #7 brushes and a mixture of yellow ochre, raw umber, and black. When the wash for the wall is dry I dip the #5 into black and suggest textures on the wall with drybrush. I use drybrush on the door as well, and add hinges. Then I "kill" the pure white of the trim with a light gray. Finally, on top of everything, I paint the posts and their cast shadows using black and grays.

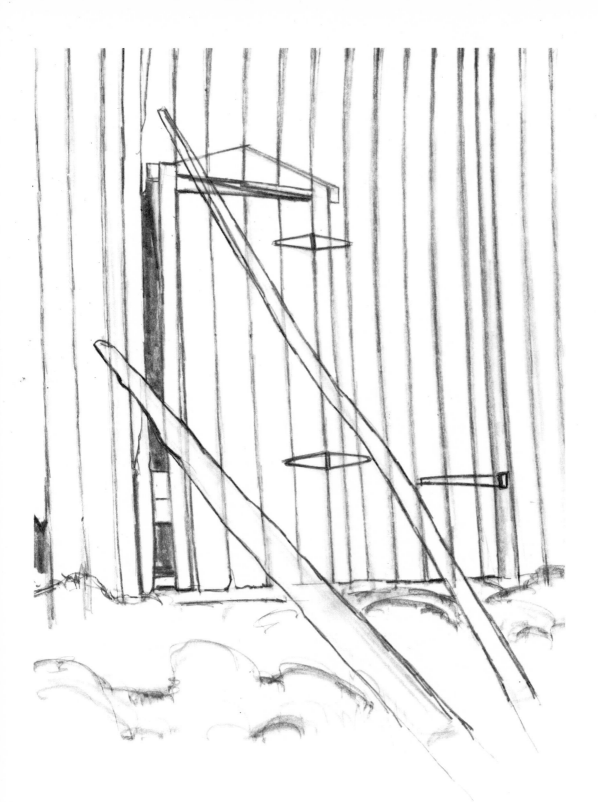

Step 2. *You've seen me do this before, in the first project. I enlarge my sketch with pencil and refine the drawing. Notice in the drawing, that I've shifted the longer pole so that it won't cross the lower hinge and make an "asterisk" with the white trim, as it does on the sketch. You've noticed also, I'm sure, that I've corrected the perspective at the top of the door. In this book I'm concentrating on the control, precision, and gradual build-up of a painting characteristic of the "magic realist" technique. I'll, of course, assume that you already know the fundamentals of drawing. If you feel shaky, then I suggest, quite immodestly, that you get my book* How to Draw What You See, *or* Learning to Draw *by Bob Kaupelis, also published by Watson-Guptill. But back to this particular job; the drawing is ready to be traced onto illustration board.*

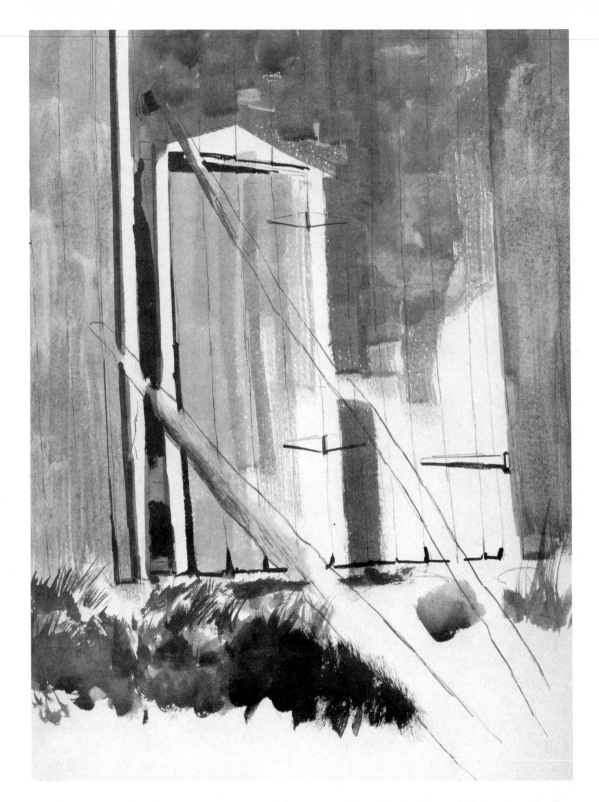

Step 3. *I squeeze opaque watercolor into my slant-and-well palette, which I customarily place at the edge of a butcher's tray. The only substitution in the list of colors I've mentioned is the flame red for the cadmium red light originally used on the color sketch. I dip into the red, black, and raw umber to get a muted red for the wall of the barn. With the #20 flat brush fully loaded with water, but with very little paint, I rub with the heel of the #20 flat brush to apply the first thin wash for the barn's wall. In this way the rough surface of the illustration board shows through. This texture will help me capture the quality of the weathered wood of the old barn. After covering the entire wall, I paint in the grass with the #7 brush, using broad masses of a very diluted mixture of yellow ochre, raw umber, and black. Then I do the poles in raw umber, black, and white. I paint only a broad indication of their form, not their texture or detail.*

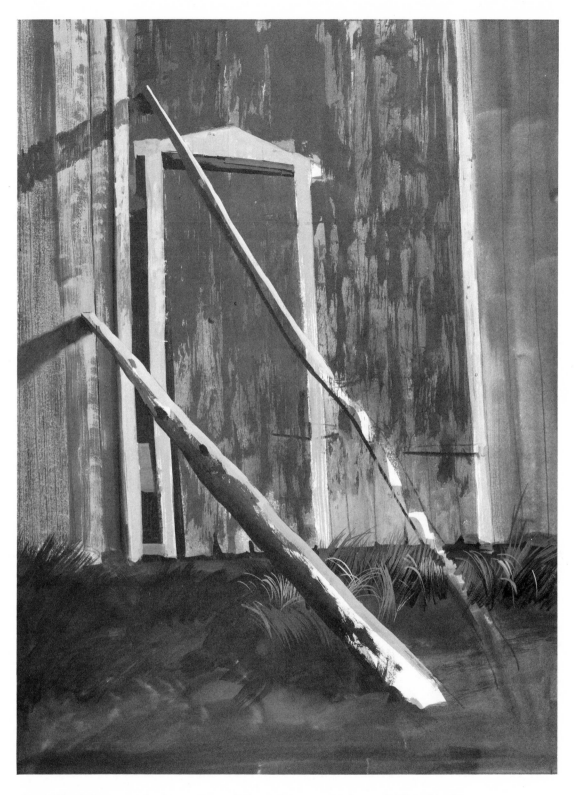

Step 4. *I begin here, over the thin washes, to indicate the textures of the wood. I'll do this with thicker pigment, dragging the #5 brush at the left of the door—the drybrush technique. I also scrub with the side of the brush, between the white trim, to suggest blotchy old paint. I've carried this effect across the poles. Even though their pencil contours still show, I've reinforced the poles with pigment so that I can continue to execute the textural qualities of the wall without fear of losing their outlines. I'll leave the poles at this stage until I've finished the grass which I've already begun. But before I give the grass the final touches, I'll finish the wall completely since the grass overlaps it at the bottom edge.*

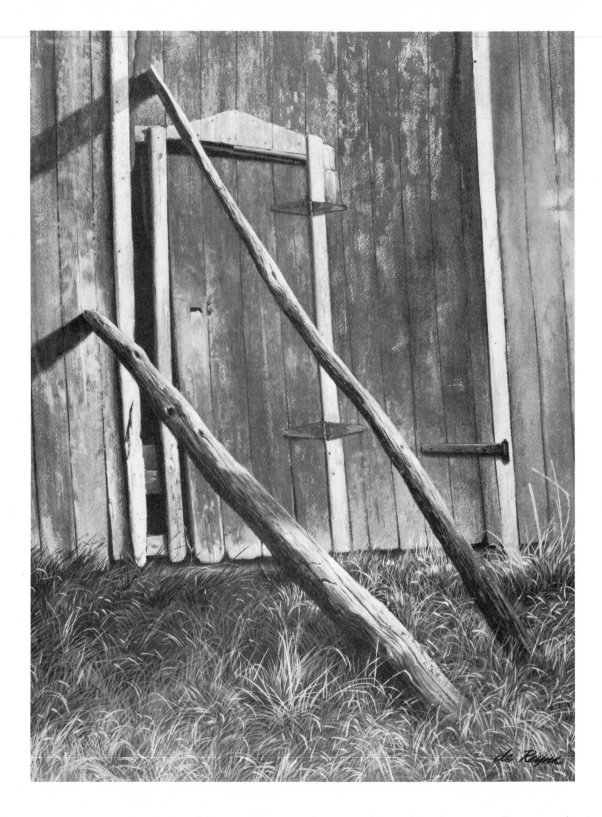

Step 5. *One of the great advantages of magic realist media is that a succeeding step can be executed immediately after the preceding one is finished, because these media dry so quickly. Now I begin the delightful process of bringing out the textures on the wall with a well "fanned" #7 brush. The rough texture of the illustration board itself is a great aid in rendering the grain of weathered wood. After I articulate the grain of the wood, I rub the heel of my brush to simulate old paint that has begun to chip. When rendering the wall I work it slightly into the white trim, into the poles, and into the hinges, because I know that using this opaque medium I can trim back ragged edges with white or whatever tone I may need. I define the grass in lighter strokes with the #3 brush over the broad foundation that I applied in Step 4.*

PROJECT 5

Sponging Off and Ruling

Contrary to prevailing opinion, you can handle opaque watercolor in a variety of ways. In this demonstration, I begin painting with thin washes. Then, after carefully articulating certain passages with thicker paint, I'll show you how to go back with a damp sponge and sponge off paint. This "sponging off" creates a soft, blurred impression—an old weathered look.

Perspective comes strongly into play with this demonstration painting, as well as the need for perfectly straight lines. To achieve the latter, you'll learn the ruling method; that is creating straight lines in paint with a ruler and a pointed brush. The "ruling method" will feel a bit awkward at first, but don't give up; you must persevere until you master it. It's an invaluable technique that will prove indispensable in future paintings.

The demonstration in this project has more steps than usual, because I had to solve the problems of perspective at the drawing stage. I want to stress this point: don't start painting until you're absolutely sure that the drawing is right.

Some of the tools that usually play a secondary role come to the fore in this project. They are: a piece of (natural or synthetic) sponge pushpins, an 18″ x 24″ ruler, a T-square with a 30″ blade, and a 14″, 45° plastic triangle. I'll explain their specific functions in Steps 2, 3, and 4. You'll also need a pad of tracing paper and an 11″ x 14″ piece of illustration board, as well as an office pencil, a 5H pencil for tracing, and a #314 "draughting" pencil. For the final painting you'll need opaque watercolor and Winsor & Newton #3, #5, and #7 pointed watercolor brushes, and a #20 flat sable.

Step 1. I sketched this view from the window of our lodgings while on a holiday in Nova Scotia. I used an Aquabee #524 tracing pad for my surface and a #314 draughting pencil. I "fixed" my drawing the moment I finished so that it wouldn't smudge. No matter how roughly I sketch a scene, I pay attention to the eye level (A) and then relate everything else to it. The horizon is the first line that I draw across the pad—even when it isn't visible because of buildings or hills. When I'm drawing a building, I use a row of windows as my eye level; if I'm drawing hills or mountains, I find the horizontal line on barn or a house. Your perspective lines don't have to be exact, just approximate them. Later, if you use your sketch to develop a painting, you can "true it up."

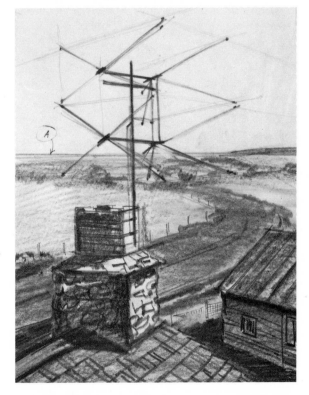

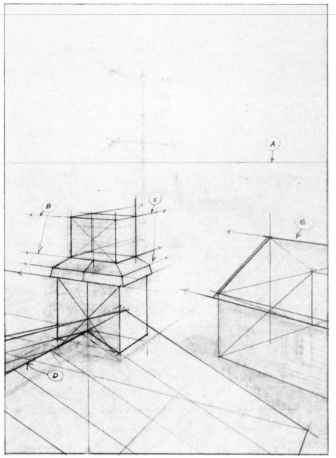

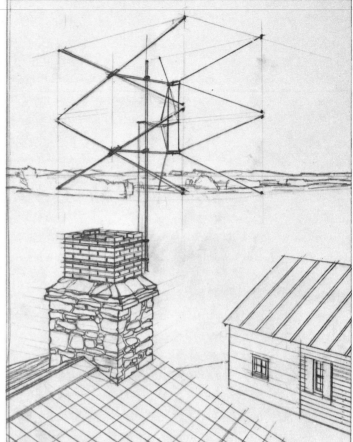

Step 2. *Later (actually over a year later) I retrieve the sketch (Step 1) from my sketch bin and place another sheet of tracing paper over it to "true up" the perspective. I use the T-square to establish the horizontal (A) of the eye level. With the triangle set against the blade of the T-square I do the verticals. Then, following the slant of lines (B) and (C) on the chimney, I set down their respective vanishing points with pushpins. In this case, the vanishing points are outside the picture area. By setting the triangle or the T-square's edge against the pushpins, I can quickly and accurately make my lines converge to the left and the right vanishing points. The X's on the cubic forms of the chimney merely indicate its optical center so that I can correctly place the peak (D) of the roof. Notice that the smaller building (E), because it's not parallel to the larger one, has different vanishing points, but it's on the same eye level.*

Step 3. *Here I've placed another sheet of tracing paper over Step 2. Still using the pushpins for the vanishing points, I draw the bricks, the stone work, and the lines on the side of the cabin. I place the grid on the roof as a guide for the shingles and define the TV antenna. In this step I use an office pencil. This, with the exception of the antenna, is what I trace with the 5H pencil to my illustration board. I've left out the road because I feel it's too distracting, and besides, it "kills" the silhouette of the buildings. If I need something to pull the composition together, I'll add an element. There's a moral here that I'll point out in the next step.*

Step 4. *I begin this step by laying in a graded wash for the sky, using the #20 square sable with a mixture of white tinted with Prussian blue and yellow ochre. I work my way down the board with thin washes that extend slightly into the foreground and buildings. Still working with very thin paint so that my traced drawing will show through, I lay in the foreground buildings. You can see pencil details on the shadow side of the chimney. Then I trace the antenna onto the illustration board. That's when it hits me! The blasted background, broadly treated as it is, competes with the antenna which I wanted to emphasize because of its incongruity with the very old buildings. So, I decide to replace the lovely river in the distance with a simple hill.*

Step 5. *Here's that hill. The only thing left of my original background is the tree peeking over the hill at the left. I paint the hill with a flat green (a combination of Prussian blue, yellow ochre, and white) that's thick enough to cover the previous wash. Then, I retrace the lower part of the antenna. I begin rendering the bricks, the stonework on the chimney, and the shingles on the roof. On the smaller cottage I also reinforce shingles with pencil. Both buildings are still in thin washes of yellow ochre and black. I go back to the hill and give it a bit of texture by stabbing downward with short vertical strokes, using my #20 sable. I use thick paint to suggest the cropped grass that the sheep have nibbled. Then I take a damp sponge and "sponge off" the roof on the smaller cottage to blur its crisp definition and give it a soft, weathered look.*

Step 6. *To delineate the antenna I use the "ruling" method. Here's how I do it. I use a #3 brush and load it with thin pigment. I work its hair to a point by tapping and rolling the side of its stock on the tray. Then I guide my brush, using a ruler, applying paint with just its tip. Then I apply another thin wash of black and yellow ochre to the smaller building. While it's still wet I tap this wash with a damp sponge to get the blotchy effect of weathered roofing paper. Again I use the ruling method to define the windows. I move over the the ground and with the #3 brush I render its texture and the small pebbles. With the same brush I define the shadow pattern of the grass. Finally, I move down into the shadow between the buildings and make it luminous by introducing lighter values into its flat dark tone.*

Opaque Watercolor Over a Painted Ground

Even though mat boards come ready-made in various tints, this time I'd like you to prepare the surface color of the board yourself. The advantage is that you can create exactly the shade you want. Another advantage is that, should you want to trim the contour of an object, you can cut back into it with the prepared background tint.

For this project you'll need the following surfaces: a 16″ x 20″ pad of tracing paper, white mounting board (cardboard faced with a smooth white paper) for sketching, a 15″ x 20″ sheet of watercolor paper, and a 16″ x 20″ piece of chipboard. For the preliminary sketch you'll need opaque watercolor (I use Marabu brand). For the final painting, you'll need the following opaque watercolor palette: permanent white, ivory black, Winsor blue, yellow ochre, and burnt sienna. In addition, you'll need watercolor brushes #2, #3, and #5, and the #20 square sable.

Step 1. Looking out my window, wondering what my next painting will be, I notice the birds at their feeder. That's it! I pick up a piece of mounting board and moisten the cakes of Marabu opaque watercolor. For these sketches I use only black, burnt umber, and yellow, since these are the colors on the birds. I think these are Connecticut Warblers, but I'm not sure. Anyway, they have light brown heads and wings, with a yellow band across their off-white breasts. For the sketches, some of them hardly more than a line scribble, I use a #3 watercolor brush. But, remember that on such a restless and mercurial model, you must practice studying it closely, and then drawing it quickly—mostly from memory.

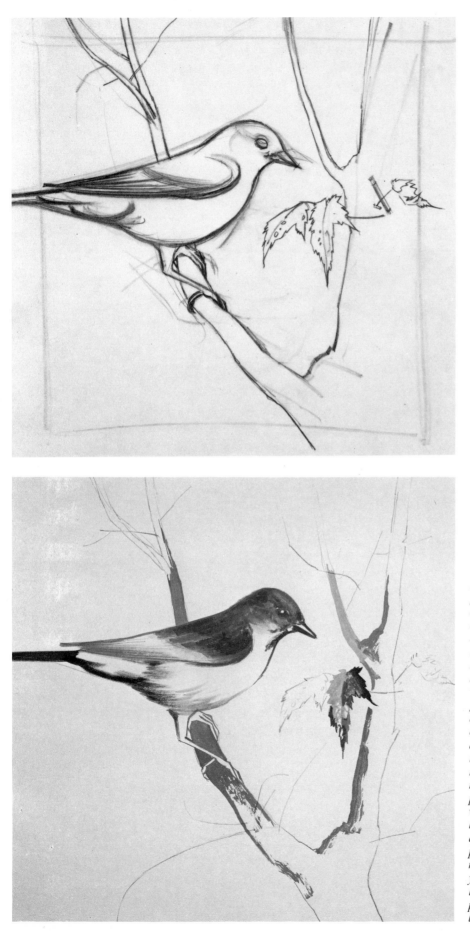

Step 2. I start enlarging and refining my drawing with office pencil on the #524 tracing paper pad, but I'm having trouble with the bird's feet. Then I think, "Rudolf, you dumnkopf! Why don't you check these details with a book on birds!" Naturally, the feet of the birds in the books aren't in the position that I need, but I can use their detail and relationship to the body. Then I get exactly the branch that I want and bring it to the studio. Originally I was going to show the trunk of the tree cropped by the right border, but I decide that just the branch will make a better design. I also resolve to make the painting an arrangement of light and dark values, more than a work with lights and shadows. Now, with the color sketches I did in Step 1, the volume on "Birds of America," and the line drawing that you see here, I'm ready to begin painting.

Step 3. In this step I create my painted ground. With ¾" masking tape I fasten a 15" x 20" sheet of Fabriano watercolor paper to a 16" x 20" piece of chipboard. Then I mix up the color for the ground. I create a warm blue by using mostly white, with a spot of Winsor blue, and a dash of yellow ochre to warm it up. I test this color on the margin of the Fabriano paper. When it dries, I find that it's too dark and too cold. So I add more permanent white and another dash of yellow ochre; I let the color dry again and check it. Now it's just right for the clear sky I want. I measure an 11¼" x 11" area on the paper and wet it with a sponge and clear water. Then with the square #20 brush I start spreading the color quickly in all directions—much as you paint a wall—so as not to leave brush marks. The result is the flat, even tone you see here. When it dries, I trace my line drawing from Step 2 and start painting with the #2 and the #3 brushes.

Step 4. *For the dark head and wings of the bird I use burnt sienna, burnt umber, and black. As you see, I'm using drybrush to create soft modulations of tone that suggest soft feathers. I give the bird's body a thin, off-white coat—white and burnt umber—right over the drybrush indications of the previous step. While this dries, I move over to the branch and paint most of it by rubbing vigorously with the #3 brush; I use white, burnt sienna, and black paint. It's now a warm, greenish gray, and the darker spots on the branch at the left are in a muted burnt sienna. The leaves are in greens and reds blended wet-in-wet. I paint the soft feathers on the body using a drybrush technique and pure thin white. With the #2 brush I cover the feet with a mixture of burnt umber and black, with lighter details on top.*

Drybrush and Glazing with Opaque Watercolor

You'll notice that in these beginning projects I'm using mostly opaque watercolor. I want you to become acquainted with this medium's characteristics which are similar to those of egg tempera. However, opaque watercolor is a bit less complicated to handle and, therefore, a good introduction to tempera which you'll soon be using.

In each of the demonstrations of this book, you'll discover that I use a variety of techniques in one painting. In this one, drybrush and glazing predominate. The drybush gives the texture necessary to simulate the weathered wood of the shutters; the glazing helps me create the subtle tones of the wall and window as well as the shutters.

For the final painting you'll need an 11″ x 15″ pad of watercolor paper. Be always on the alert for an interesting paper surface. Illustration board is really just cardboard with watercolor glued on top of it by its manufacturer. So, why not get plain cardboard and glue your favorite paper on it as I've done in this demonstration? I've found the best adhesive to be Liquitex polymer gloss medium by Permanent Pigments, Inc. You'll also need #3, #5, and #7 watercolor brushes and a #20 flat sable. You'll be using the following opaque watercolor palette: ivory black, white, yellow ochre, burnt umber, Winsor blue, and olive green. You'll also need the tracing paper, a 5H and a #2 office pencil.

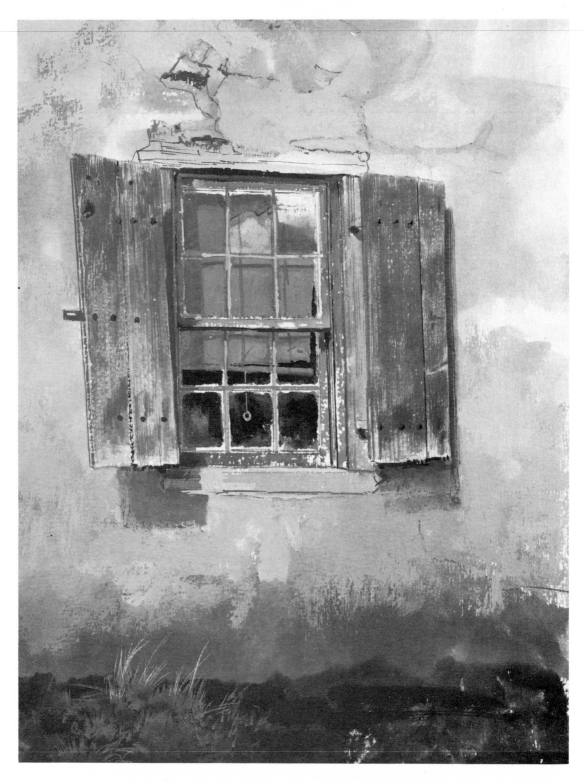

Step 1. *I begin this demonstration with a watercolor sketch that I did on-the-spot. I used a very diluted mixture of yellow ochre, burnt umber, and black for the wall. I applied this with my #20 flat sable brush. Using the same colors, but less diluted, I paint the cracks on the plaster with the #3 watercolor brush. I paint the window-shade with a very thin wash of mostly yellow ochre tempered with burnt umber and black. The cast shadows on the shade consist of the same colors, but I use more black and umber than yellow. The shutters and the window are predominantly Winsor blue, subdued with white, burnt umber, and black. The white flaking off effect on the window frame I achieve by using quick strokes with the #3 brush on the board's rough textured surface.*

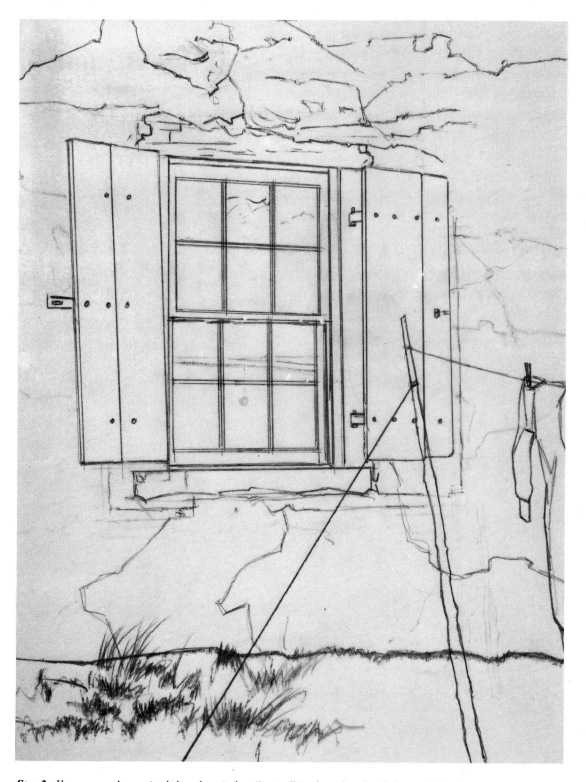

Step 2. *I'm sure you've noticed that the window "swims" in the color sketch because there's nothing to "anchor" it to the ground, the other main element in the picture. So, I place a sheet of acetate over the color sketch and try the following. First, I place a bush, overlapping the shutter on the right, but it's too distracting. Then I try a vine climbing up the wall. Yes, this is what I need. I know there's one on the neighbor's garage; so I take my pad over there. That's it, the perfect link—a clothesline! I do a careful drawing of the pole, the line, and the guy wire. Then I place a sheet of tracing paper over the sketch, refine the line drawing, incorporate the clothesline, and trace it with the 5H pencil to another sheet of Watchung watercolor paper that I've previously glued to a piece of bare cardboard. I use Watchung 140 lb., #533-CL manufac- tured by Bienfang Paper Co. It's thick enough so that it won't buckle and has an agreeable rough texture.*

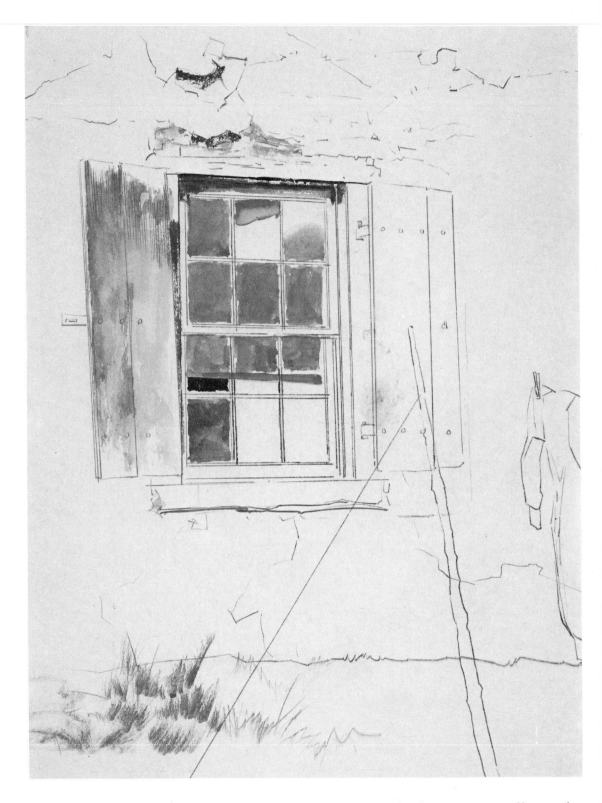

Step 3. *I begin the actual painting with very thin washes that are a mixture of burnt umber, yellow ochre, and black. I want not only to establish facts, but to "feel" the different textures of glass, rough plaster, weathered wood, and even the grass, paint over and cover completely with the ground color. I start with a monochrome of umber and black, because I plan to create the blue of the shutters with a glaze of yellow ochre (over the burnt umber and black). Painting directly with either blue or yellow ochre won't give me subtleties of color and texture—the main things I found appealing about this particular subject. Notice, however, that right from the beginning (I've been painting no longer than eight or ten minutes) I've already established the lightest value (the upper right windowpane) and the darkest one (the value below the shade, on the left). From here on, I must key all the other values to these two.*

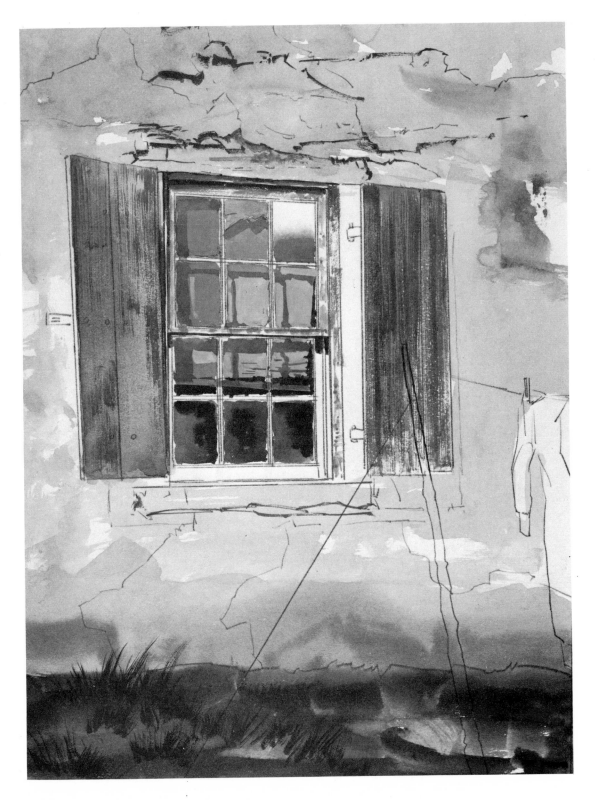

Step 4. *Still thinking that the window might "swim," I've made the wall darker than I anticipated, but it won't be any trouble to make it lighter. With my #3 brush I begin here to indicate its cracks. I glaze the shutters with mostly water and a touch of Winsor blue, using the #5 brush. Then, working with the #3 brush, I dip into a mixture of blue and white, to which I add a whisper of burnt umber to "age" it. I use this mixture with drybrush to create the worn texture of the wood. I exaggerate the peeling paint of the window frame again with drybrush, because I can easily smooth out any areas that become too insistent. When I reach the ground I paint the grass dark against light, as you see, but I change my mind in the next step.*

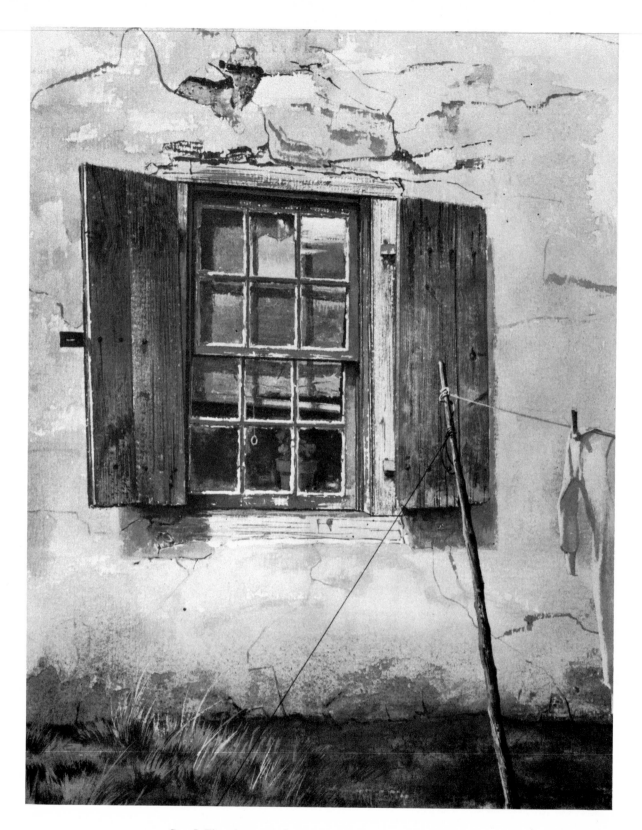

Step 5. *The advantage of using opaque watercolor is that if a value turns out to be too dark, it can easily be lightened by adding white to the colors originally used. Notice I've made the wall lighter to make the window stand out. I use the #20 flat sable brush on the wall, working some of the tonal transitions wet-in-wet, especially where they meet the ground. The cracks and the broken plaster I delineate with the #3 watercolor brush. After defining the details of the shutters with drybrush and burnt umber and black, I give them another glaze of Winsor blue. Later I again accent some details with drybrush that are subdued too much by the glaze. The color on the ground is the same as the one I used on the original sketch.*

PROJECT 8

Opaque Watercolor Over Ink

Coming out of my studio for a breather, I spotted this container that my daughter was using while weeding the garden. She too, evidently, was "taking five." Of course, she was delighted when I asked her not to remove it for a while. It was one of those things that I simply can't resist drawing, especially the gloves. I've always considered the *how* of picture-making vitally important, but I must also remind you that the *why* is indispensable. You, as the artist, should respond to the moods of nature and man, and create the images that testify to your emotional involvement. You'll see me render this demonstration using at first, only ink, to initiate the modeling, the textures, and the tonal scheme. The advantage in painting with opaque watercolor over an ink drawing is that, once the ink is dry, you can scrub or wash over the ink without disturbing it or losing you linear structure.

You'll need the following surfaces for this project: a 16″ x 20″ pad of tracing paper (or sketching paper) for your sketch. I use an Aquabee #565 vellum pad. Also, you'll need a piece of pebbled mat board—white on one side and gray on the other—for your final painting. In addition you'll use extra dense, India ink (I use Artone), a synthetic sponge, #3, #5, and #7 watercolor brushes, a 314 draughting pencil, and a hard 5H pencil for tracing. You'll need the following opaque watercolor palette: ivory black, white, burnt umber, yellow ochre, flame red, and Winsor blue. I, of course, use Designers' gouache colors for this one and most of my other demonstrations done with opaque watercolor.

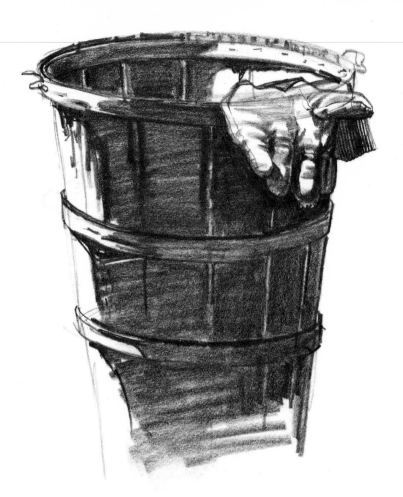

Step 1. *When you find the object that strikes a cord in you, draw it straight-away. After seeing the basket, I go back to my studio and pick up the first pad I come to. It turns out to be vellum, which is fine for pencil drawing. I sharpen three or four draughting pencils, and start drawing with the pad on my knees. The main things I'm after are the gesture of the gloves and, of course, the light and shadow pattern of the whole thing. Usually my sketches are small but this one measures 8" across the top of the basket. Later, however, I was glad I'd done the drawing this size, because I can use it for my painting without having to enlarge it.*

Step 2. *Exactly a year later to the month, I saw my daughter going through her chores again, and there was the same basket. So I went to my sketch portfolio and pulled out the drawing to see if I could use it for a painting. As ideas popped into my mind, I set them down on a 16" x 20" sketch pad. I show you here only the sheet that has the "rough" that I chose to develop. It's at the upper left corner. It's upside down, because I have the habit of rotating my pad as I sketch. Beginning at the lower left corner I work my way around the pad, turning it, as I go on to the next sketch. Why don't I begin at the top and have all the sketches right side up? I think it's because I want to explore as many different approaches to the subject as possible without being influenced by the previous attempts. I use a draughting #314 pencil, and, purely by coincidence, another vellum pad #565.*

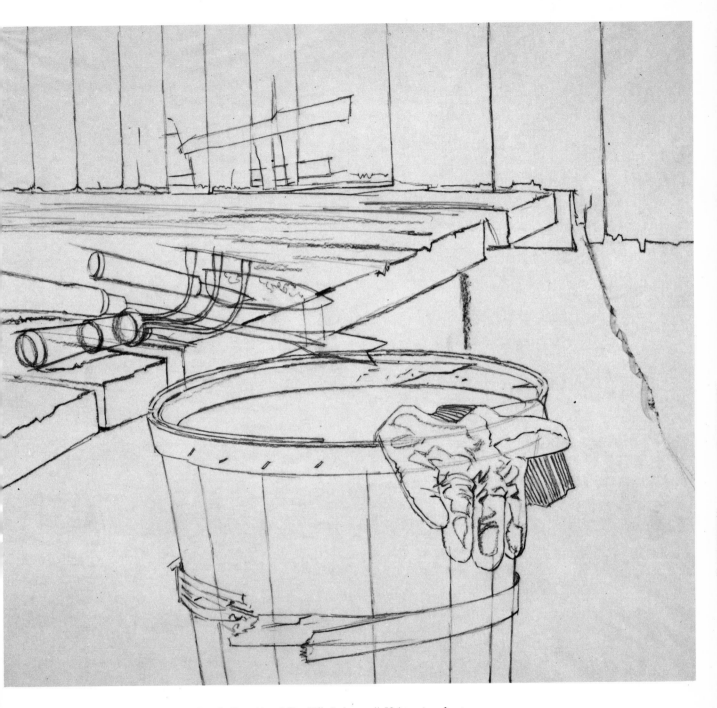

Step 3. *After I enlarge the rough sketch (Step 2) to 16" x 20", I place a #524 tracing sheet over the original drawing of the basket (Step 1) to get its linear structure. Then I tape in position this tracing sheet that contains the basket image onto the enlarged drawing of the background. I also trace the wall and the slanting deck on to the enlarged drawing, still using only line. Taking still another sheet of #524 tracing paper, I trace both background and basket onto it, refine the drawing of the tools, and shift things about to get the best composition. I've concentrated on the linear rhythms, because they're all I need to trace to the pebbled mat board.*

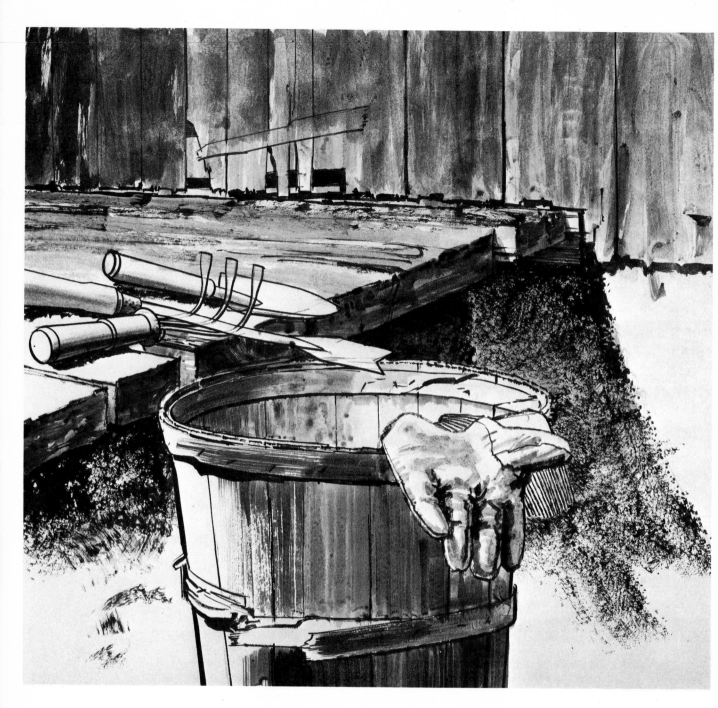

Step 4. *After tracing the line drawing to my pebbled mat board, I begin to lay in tonal values using the tonal scheme I've developed in Step 3. I do this in full strength India ink. To get the dark, the medium, and the light grays, I dilute the ink. By squeezing water from my sponge onto the butcher's tray, and then adding ink to the water with an eye dropper or with a brush, I prepare a large puddle of medium gray ink. Then, for the lighter tones, I dip my brush in the water jar and work it on one edge of the gray puddle. To get darker tones, I dip into the ink bottle and work the brush into the other side of the medium gray puddle. I use mostly the #7 watercolor brush; I use the #5 for smaller details. For the plaster behind the basket, I use a synthetic sponge to create texture. As I've done in preceding projects, I strive to cover the entire surface as quickly as possible to establish the tonal scheme. I'm aware of the character of the edges, the modeling of the forms, and textural qualities, but they're only broadly indicated here—not rendered.*

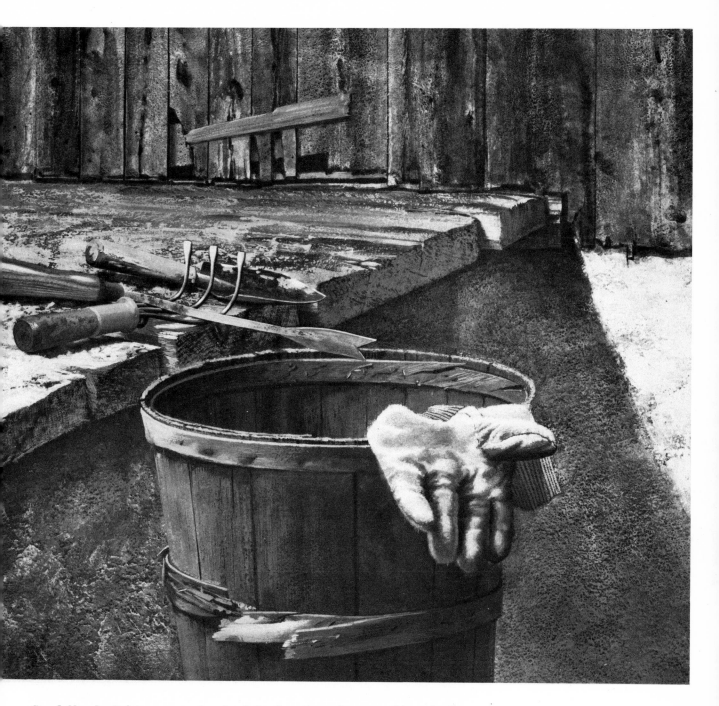

Step 5. *Now I switch to opaque watercolor. I give the entire surface a very thin wash of burnt umber tempered with a spot of ivory black. This kills the glaring whites that remain on the bare board and pulls everything together. The advantage of using India ink before applying opaque watercolor is that, being waterproof, you can scrub or wash over the ink without disturbing it in the least. I rub the heel of my #7 brush on the slanting deck and on the plaster wall using layers of yellow ochre, burnt umber, black, and white that vary in consistency from thin applications to thick impasto. Then I give the basket a glaze of flame red that's muted with black. For the gloves, which are a soiled white, I use scumbles of yellow ochre, burnt umber, black, and white. I apply the scumbles with the #5 brush using medium thick pigment. In some areas I stipple the strokes to create the soft texture of the cloth. The knitted bands of the gloves I paint with Winsor blue which is subdued with umber and white. I apply these tones with the point of the #3 brush. Then I go back to the basket for final rendering of details.*

PROJECT 9

Working Thick and Thin with Acrylic

Acrylic is a marvelously versatile medium. With it you can render thick juicy impasto or thin transparent veils of color. You can change the brushing consistency of acrylic merely by varying the amount of medium—water—that you mix with it. The less water you use, the more thick and juicy your paint, and vice versa.

In this demonstration I'll introduce you to both extremes. We'll start with a thick underpainting in black and white acrylic. Over this you'll use your paint to produce transparent layers of color. Thus you'll build up various textures and hues. This process of building up paint to achieve texture and tonal values is the hallmark of the magic realist approach.

As in previous demonstrations with opaque watercolor, I begin with a color sketch done with my Marabu opaque watercolors. In addition, you'll see me use gray pastel and white Conté for highlights in this color sketch. For the final acrylic painting you'll need a piece of chipboard (which is simply uncoated, medium-gray cardboard). You'll have to prime the chipboard with white casein to create a proper painting surface. Besides the usual watercolor brushes and painting knife, you'll need the following acrylic palette: acra red, yellow ochre, cerulean blue, Mars black, and titanium white.

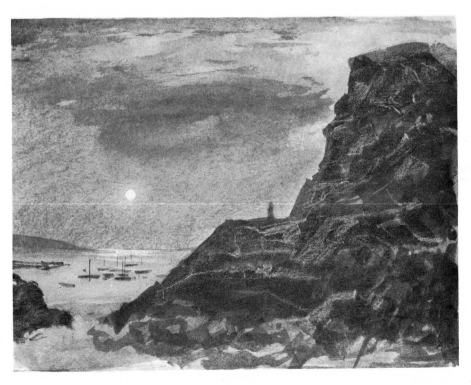

Step 1. There will be many times, unfortunately, when the proper materials will not be available and you'll have to use whatever stuff you may have with you. When the fog started rolling in at this spot in Nova Scotia, I had no watercolor paper or board with me, so I took my #307 Ad Art pad (which is thin paper only suitable for dry media) and did the watercolor sketch you see here. It measures 6½″ x 5″. I think the reproduction will show the crinkling of the paper, but just the same, I was delighted to pin down the effect I wanted. This sketch took only a few minutes but by the time I finished, the fog had gotten thicker, so on returning to my lodgings I went over the sky with my gray pastel. I went over the rocky shore with white Conté, and then "fixed" the sketch. I used only the #5 watercolor brush for this sketch, and a tube of white opaque, in addition to my watercolors.

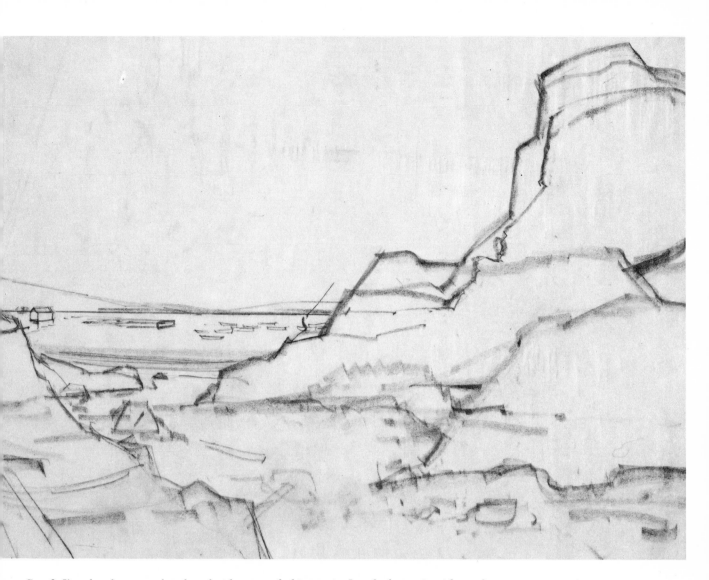

Step 2. *I've already prepared my board with a coat of white casein. I apply the casein with my #20 flat brush, using criss-crossing strokes to create a smooth layer of paint. Armed now with the color sketch and a careful pencil rendering (which I haven't shown here) I'm ready to re-arrange, if necessary, and compose the final painting. My original color sketch is too evenly divided with the big shape running from corner to corner. I need a larger shape at the lower left to stop such a strong diagonal movement. In this step you can see the main shapes that I decide to trace to the chipboard. I transfer only the big divisions to my chipboard, because I'm going to develop the rock formations mostly with my painting knife, and I'll only add detail to it in the last stages.*

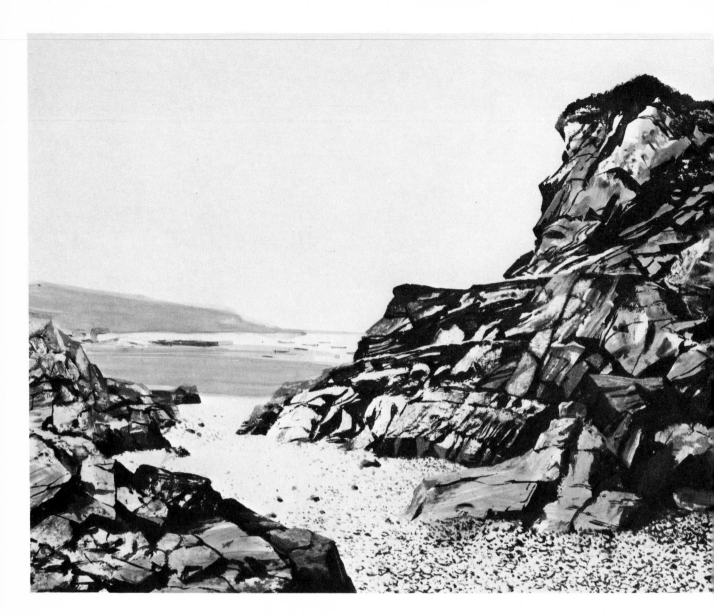

Step 3. *Here I paint the grass at the top of the cliff, as well as the distance and the pebbles on the ground, with acrylic that has a regular brushing consistency. However, for the rocks I use a thick gray impasto mixed from acrylic titanium white and Mars black. I apply this impasto with my painting knife. The texture this impasto creates is the main thing I'm after at this stage. To avoid monotony of texture, I pat with the knife, scrape hard with its edge, and then drag it lightly with its blade flat against the painting surface.*

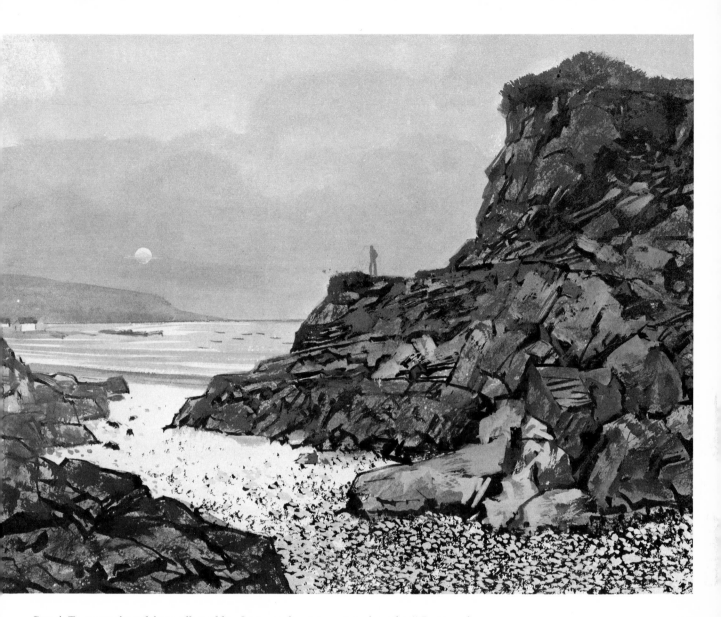

Step 4. *To create the soft hazy effect of fog, I now work wet-in-wet, and use the #7 watercolor brush. I paint quickly so I can blend one tone softly into the other. I use mixtures of white and yellow ochre, and also mixtures of cerulean blue, white, and black—with a whisper of acra red— to create the necessary cool and warm grays of the fog. Here I also introduce the figure I had in the original sketch, because it gives the picture scale. Still using the #7 brush, I cover the rock formations with a thin film of white, blue, and acra red acrylic. The pervading color on the rocks becomes a gray-mauve because of the "veil of color" that I glaze over the black and white underpainting which I did in Step 3.*

Step 5. *What remains now is dessert. I go over the entire sky, using thicker pigment. I blend the edges of the sky wet-in-wet with the # 7 brush to create more softness. I subdue the color on the swells and on anchored boats to make both very close in value, so that they're hardly visible through the fog. The effect I'm striving for is a hazy and indefinite one in soft pearly tones. Check for yourself to see how fog or rain mutes local colors and throws a "veil" over the scene.*

Impasto with Acrylic

Impasto, the application of thick pigment to create rough texture, is a technique usually associated with oil paint. However, this technique forms a large part of my magic realist approach. Impasto works best with acrylic and gouache, or opaque watercolor. In this project I'll demonstrate my basic procedure for creating impasto with acrylic.

For this project you'll need #3 and #4 pointed sable watercolor brushes and a #20 flat sable brush. Since it takes a minute for the acrylic to harden, rinse your brush the moment you stop using it, even during a painting session. You'll use a double thickness, medium surface, 11″ x 14″ illustration board for the acrylic painting. Don't use any support thinner than double thickness illustration board, or your painting will buckle. You'll use black India ink, along with a 404 Gillott pen and pen holder, to reinforce your drawing. You'll also need the following acrylic colors: Mars black, titanium white, raw umber, and ultramarine blue. In addition, you'll need both a drawing pad and tracing paper along with a #314 draughting pencil.

When you're through for the day, wash your brushes thoroughly with warm water and a mild soap. Be sure to mold them to their original pointed or flat shape as you squeeze the water out (forward to the tip) between your fingers.

Step 1. *In this demonstration I vary my basic procedure and begin with a pencil sketch rather than a color sketch. The rough stone walls and one of the doors of this building captivated me. I immediately make a careful study using an HB pencil for the thin lines and a draughting #314 pencil for the darker accents. I begin in pencil so that I can capture accurate and faithful detail in the shortest possible time. (It's late afternoon, and shadows change quickly.) The color of this scene presents no problem; it's mostly a matter of black, white and raw umber.*

Step 2. *I tape my drawing (done on an Ad Art, 11″ x14″ x 14″ sheet of paper) at the top of an 11″ x 14″ piece of illustration board. Then I trace only the most important lines and configurations onto the illustration board. When I have the main shapes traced, I reinforce them with India ink using 404 Gillott pen. I do this to be sure the line drawing won't be obscured by the impasto and drybrush that's to follow. Now I pick up acrylic titanium white with the underside of my painting knife and apply it thickly to create an impasto following the configurations of the wall as closely as possible. This impasto gives the walls the rough texture they require. Then, with a "fanned" #4 watercolor brush, I begin the texture on the door with drybrush.*

Step 3. *I give the impasto a chance to dry (usually not less than an hour, since it's such a thick application of paint). Then I begin to glaze this impasto. In this particular instance the glaze is a mixture of black and raw umber in about equal proportions with a large amount of water, so that the glaze goes on as a transparent film. I apply the glaze with a #20 flat sable brush. As I apply the glaze to a small area, say two or three of the stones, I rub it with my finger while it is still wet to bring out the light areas you see in the upper left corner. Notice that I carry the drybrush and glazing slightly into the coat, so that when I paint the coat later, it won't appear to be cut out and pasted on top of the door.*

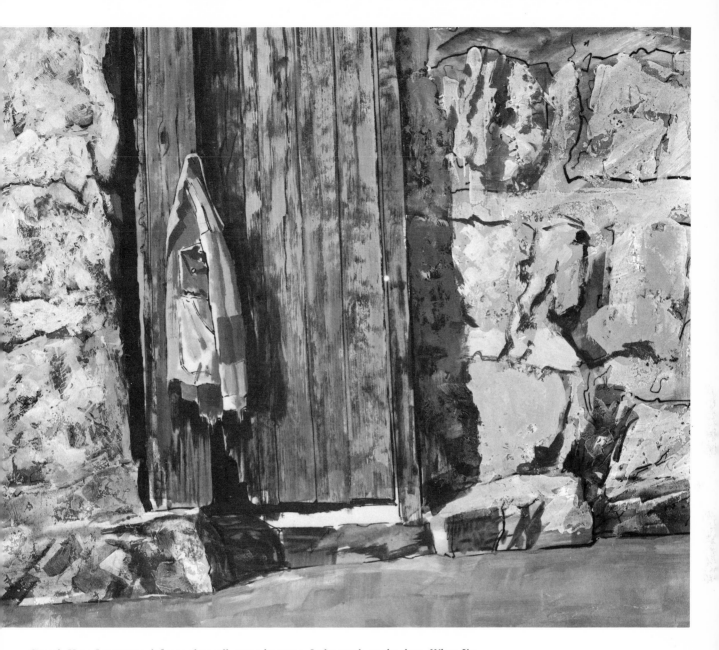

Step 4. *Here I continue defining the wall, stone by stone. I also work on the door. When I'm ready to paint Joe's coat, I hang it in the studio and throw a light on it that's consistent with the angle of the light in my original drawing. I go over the woodwork with a drybrush (and a #3 sable) but this time I use light pigment over the already dark, glazed surface. Where the dark grain of the wood gets obscured, I immediately rub off the light pigment with my finger to let it show through. In some areas I go over the woodwork again using a thin dark gray composed of raw umber and black. I even use pure black on some of the knots and cracks between the boards. Finally, I add ultramarine blue to the umber and render the coat with a wet-in-wet technique to simulate its soft folds and limp cloth. These qualities provide a contrast to the firm textures of the door behind the jacket.*

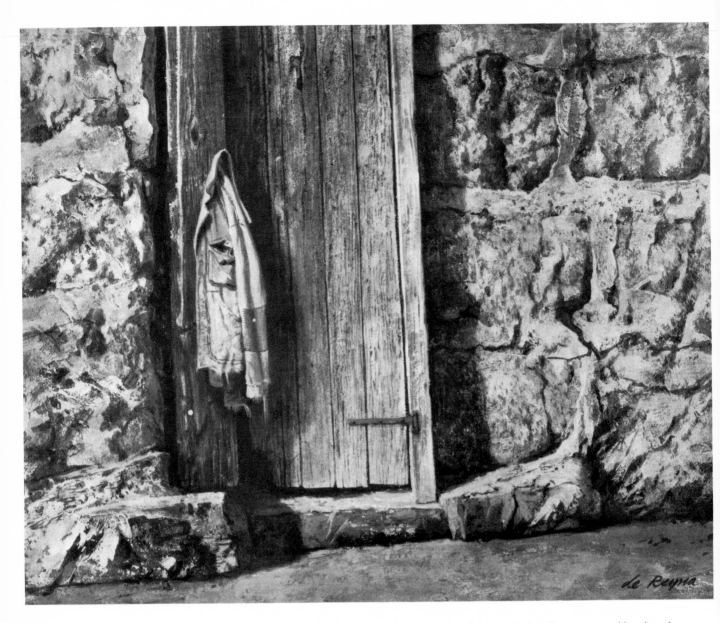

Step 5. *The main thing I want to stress in this final step is that I've suppressed brushwork as much as possible, and given the object itself paramount importance. This is the approach I've taken in every one of the projects, no matter what the subject, since my intention is to capture the "magic realism" of the motif itself and not to display any brushwork pyrotechnics. Even though I've used several techniques in this painting—wet-in-wet, impasto, drybrush and even my finger—they must all convey the form, texture, and color of the subject matter, not draw attention to themselves. The last things I do here are the textures on the ground which I scumble in. The fine threads on the frayed sleeves, the stitches on the patch, and the hinge on the door I delineate with my pointed #3 sable.*

Mixed Technique with Acrylic

Acrylic is a wonderfully responsive medium. With liberal amounts of water you can use it to produce washes that are very close to those possible with transparent watercolor. Straight from the tube you can use it to produce the thick, juicy impasto usually associated with oil paint. In this demonstration you'll use acrylic to produce both washes and impasto, the former for the sky and the latter to create the texture for the stone fence.

I begin the painting for this demonstration with a pencil sketch that contains color notations. You'll need paper thick enough so it won't crinkle when using the opaque watercolor, and yet thin enough so that you can trace the drawing to the illustration board that you'll use for the finished acrylic painting. For the sketch you'll need several sharpened pencils—grades 5H, 2B, and 4B—and #3, #5, and #7 watercolor brushes, plus a #20 flat sable brush. You'll need a painting knife and the following acrylic palette: titanium white, Mars black, raw umber, yellow ochre, and ultramarine blue.

Step 1. *Driving around with my family looking for a suitable picnic spot, I suddenly discovered this beautiful gate flanked by marvelous stone textures and cradled in tall "furry" grass. It was late afternoon and I realized the effect should be captured quickly before the shadows shifted. I did this study in B and 4B pencil. Then using "Marabu" watercolors, I took color notes (those streaks of tone in the upper left) of the weathered wood, the stones, the grass, and even the ground. I also "pulled out" and enlarged unique details, like the grooves on the frame of the gate.*

Step 2. *The next morning in my studio I decide that an area 14⅜" x 9⅛" would suit the subject. I trace my drawing on to a double thickness, cold-pressed Crescent illustration board. But now the problem of composition rears its head. The horizontal movement set off by the shape of the stone fence is so strong that it sweeps the viewer's eye to the left and then to the right, right out of the boundaries of the picture. To correct this, I need another element somewhere in the composition. From my imagination, I sketch a tree on a sheet of tissue paper which I place over the entire traced drawing just to see if it works. I push the tree behind the fence, as you see here. That seems to work.*

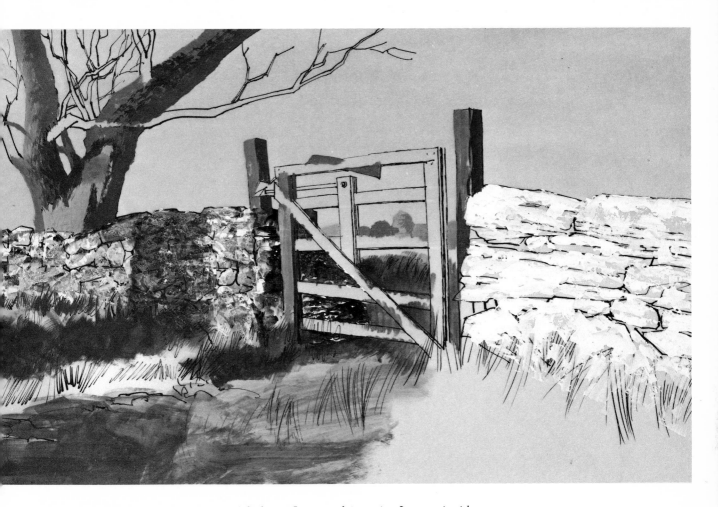

Step 3. *To insure that my line drawing won't be lost as I start applying paint, I go over it with a 404 pen and India ink, just as I did in Project 10. When the ink dries, I float a very thin wash of cerulean blue and yellow ochre acrylic over the entire sky area. I use slightly more yellow than blue because I want to preserve the amber glow of the sky. If I had painted the sky in an opaque manner, its luminosity would have been lost. To lay in my wash, I turn the drawing upside down. Using horizontal strokes with the #20 flat sable brush, I work the wash (previously mixed and then tested on scrap paper for value and color) all the way across from side to side and down to the bottom edge which is the top of the picture. The ink line still shows through. While the sky dries, I turn the board right side up and start applying an impasto on the stone fence with a painting knife, using titanium white acrylic straight from the tube. In about an hour, the impasto is dry enough to begin glazing using my #20 flat sable with a thin mixture of raw umber and ultramarine blue.*

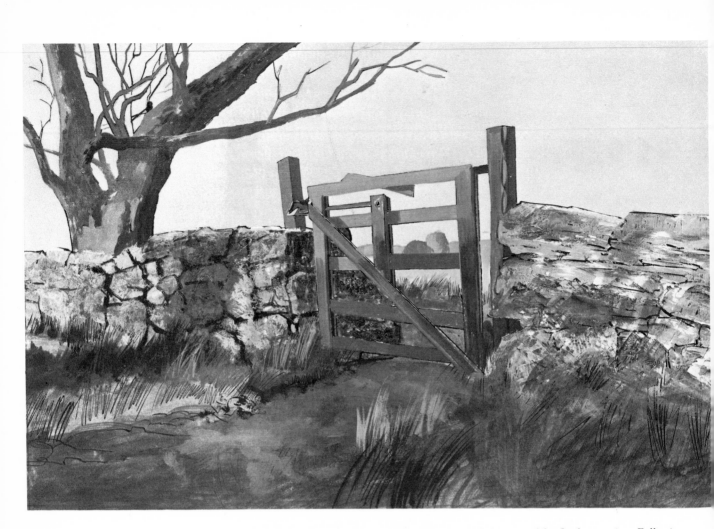

Step 4. *By the time I reach this stage, I've prepared the ground for final execution. Following the principle of working from the back forward (doing the objects that are "behind" first), I start finishing the background seen through the gate. Then with the #3 and the #5 brushes I begin to bring out the character of the tree. Notice in the final painting that I've subdued some of the branches and twigs you see here because I feel this area is a bit too "jittery." After glazing the right-hand portion of the stone fence, I begin to scumble the left section with the #5 brush. I paint the gate in flat color without values. In the final step I'll add to it with drybrush which will weather the wood.*

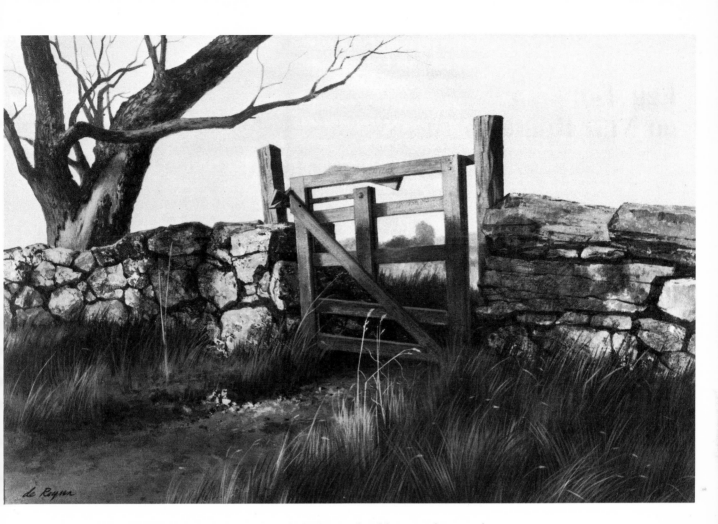

Step 5. *Now I begin the definition of edges: soft on the background and foreground grass and hard on the fence and stones. I delineate texture on the bark of the trees and wooden gate using the drybrush technique. I keep the lights warm and the shadows cool. While deepening a shadow or the contour of a stone, I modify, if needed, the lighter area adjacent to it. You can do this easily using acrylic because it dries so quickly. I keep shifting from one area to another trying to carry the entire picture forward at about the same degree of completion but not really putting the last touches anywhere. With ultramarine blue, raw umber, and black I work on the cast shadows on the grass and the fence. Finally, with yellow ochre, I articulate the grass with upward sweeps of the #3 pointed brush.*

PROJECT 12

Egg Tempera on Mat Board

Superimposing thin washes of paint over an underpainting—to create various hues and tonal values—is the essence of the magic realist approach. My purpose in using other media in the preceding projects was to acquaint you with the same deliberate and methodical procedures that egg tempera requires, but to spare you the discipline of a completely new medium right at the beginning. Now, with the painting in opaque watercolor and in acrylic behind you, you're ready to explore the unique and fascinating aspects of egg tempera.

I use the classic egg tempera approach in this demonstration. That is, after I trace my drawing onto my mat board, I reinforce the line with India ink. Then I add tone to my drawing with washes of ink. This tonal foundation will show through the layers of thin egg tempera that I'll be applying later and will give me warm and cool grays.

For this project, you'll need the following surfaces: a 16″ x 20″ sketching pad, a tracing pad (I use Aquabee's #524) and a piece of medium blue mat board. My finished painting is 12⅝″ x 10⅛″. You'll also need India ink, Winsor & Newton #3, #5, and #7 watercolor brushes, and egg yolks to mix with the powdered pigments to create tempera. I used two yolks for this painting. You'll also need the following palette of powdered pigments: light red, yellow ochre, ultramarine blue, ivory black, and white. A butcher's tray and china saucers are necessary for mixing and holding the paint.

Step 1. *To me, probably because a car has always been my sketching companion, there's something very poignant about the wreck of one, so I've sketched and painted many of them. When I saw this "carcass" lying in a friend's backyard, I just had to get my pad and record its pitiful condition. I begin this demonstration with a tonal pencil sketch, rather than a color sketch because I want to pin down, as quickly as possible, the stark skeleton against the sky and make it a sort of monument to all cars out of the running. Besides, I'd rather create, away from the subject, whatever rusty variations will enhance the mood of this painting.*

Step 2. *The moment I get back to my studio, I do a line drawing because I want accurate information about detail without the obfuscations of shadow. Remember that thoroughly precise preparation is the keynote of the egg tempera medium. Of course, a picture done in this technique could be altered later, but it's better to prevent such "grief." Notice here that I even draw the parts of the car that will eventually be covered to a great extent by the grass. I use an office pencil and a tracing pad, as I did on the sketch (Step 1), and then "fix" the drawing so it won't smudge.*

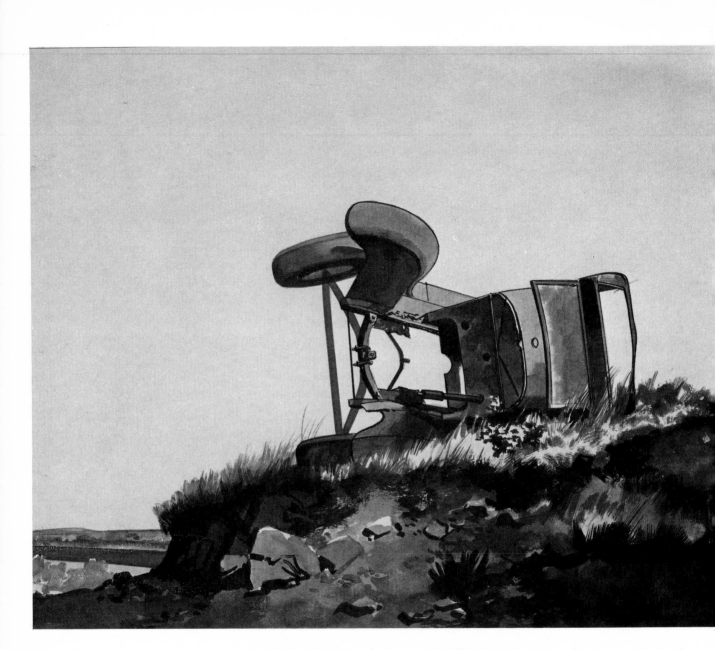

Step 3. *After I rearrange the foreground and lift the road to give it a better perspective in relation to the eye level, I take the line drawing from Step 2 and trace it onto my medium blue mat board. You can also use a gesso panel as a support for your painting. See the Materials chapter for instructions on how to prepare such a panel. Now I set up my butcher's tray and take two of the cups from the china nest. (I got mine in New York from Sam Flax, Inc. They have branches in Chicago, Los Angeles, and San Francisco, so order their catalog.) Then, in one of them, I dilute the India ink to a light gray, and a medium gray in another to create tones. With the India ink full strength from the bottle, I define all the contours of my drawing. I use the #3 and #5 watercolor brushes. I make sure that the contour of the car is clear and definite so that it will show through the white clouds that will slightly overlap it in the next step.*

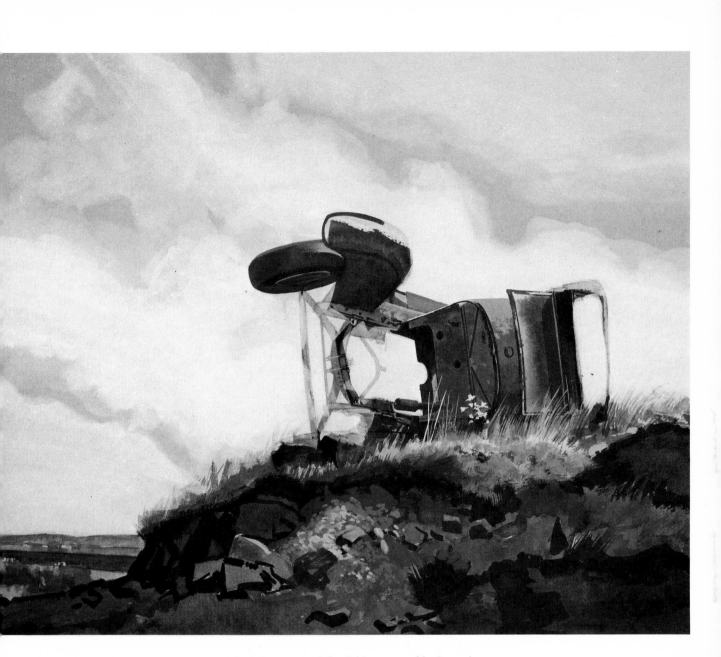

Step 4. *First I wet the entire sky area with clear water and the #20 square sable. I run the brush across the car; India ink is indelible and wouldn't be disturbed by the water. Then with the #7 brush, I dip into the water jar and on the tray I thin out some egg tempera. (See the Materials chapter for complete instructions on how to mix up your egg tempera.) While the board is still wet, I quickly indicate the clouds, working them into the car as you see here. When the clouds dry, I start regaining the silhouette of the car with the #3 brush using a mixture of black, white, yellow ochre, and light red to get the rusty color. I go back to the sky and soften some edges with a damp (not wet) #5 brush. I start rendering the foreground using mostly the #3 brush with a mixture of yellow ochre and ultramarine blue to get the warm and cool greens of the grass.*

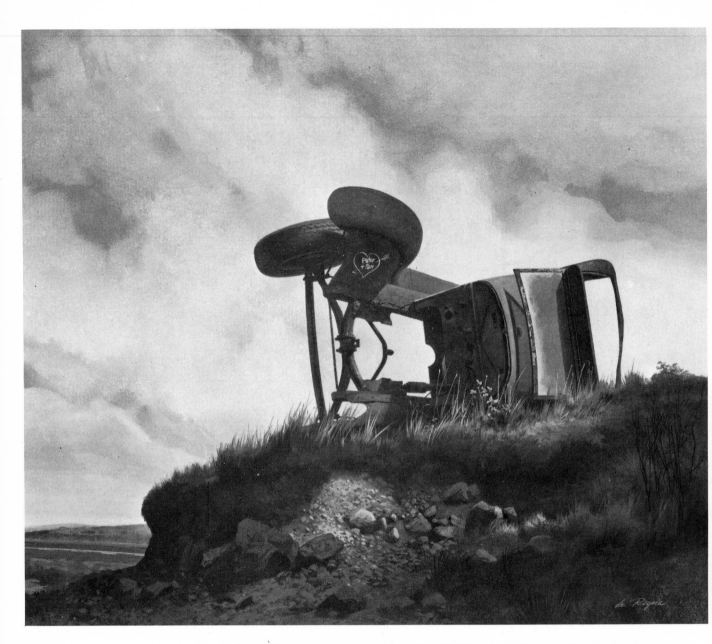

Step 5. *Here, I concentrate on the wreck itself. Using the #3 brush exclusively, I begin tapping on thick red, yellow, and black for the fenders, the cab, and the chassis. Then, after wetting the edge of the windshield glass, I let a thin mixture of ultramarine and yellow ochre spread into it, but not touching the light value that you see around the frame. Next, with thick pigment and blue, yellow, and red, I paint the windshield's frame to create the oxidized greenish blue patina. When I finish the car, I render the tall blades of grass that overlap it. Then I move to the asphalt road and use a mixture of blue and black and a touch of yellow for it. For the dividing stripes on the road I use the ruling method. The graffiti I've scribbled on the fender is primarily to commemorate my friends' names.*

Egg Tempera on a Gesso Ground

In the preceding project you worked with egg tempera on mat board. Here you'll use the more traditional surface for egg tempera—gesso panels. You can prepare these gesso panels yourself (see the Masonite section of the Materials chapter for complete instructions). For your panels you'll need a pint of white acrylic gesso and a 16″ x 30″ piece of Presdwood that's ¼″ thick. You can get Presdwood in any lumberyard. In addition, to prepare your panels you'll need medium and fine sandpaper and a 2″ housepainter's brush.

For your preliminary sketch you'll use a pad of tracing paper and a draughting pencil. You'll also do a tonal sketch to nail down values before you begin painting in egg tempera. For the tonal sketch you'll need HB, BB, and BBB carbon pencils, white Conté, a paper stump, and a piece of buff charcoal paper. For the final painting in egg tempera you'll need egg yolks and the following powdered pigments: burnt sienna, burnt umber, yellow ochre, black and white.

Step 1. *After setting up the loaf of bread on the bread board and placing the knife in countless positions, I do several sketches to see how the subject "frames up," which is my own expression for referring to a well-balanced composition. I use the draughting pencil on tracing paper, but after many roughs I'm still completely dissatisfied. My wife immediately sees the problem and pointing to the bread knife asks, "Why are you using such an ugly shape?" That's it! It's the blasted knife that's ruining the whole thing. The moral here (besides getting a spouse who is also an artist) is that all the shapes in your composition must work well together. If there's a jarring element in your composition, substitute another for it.*

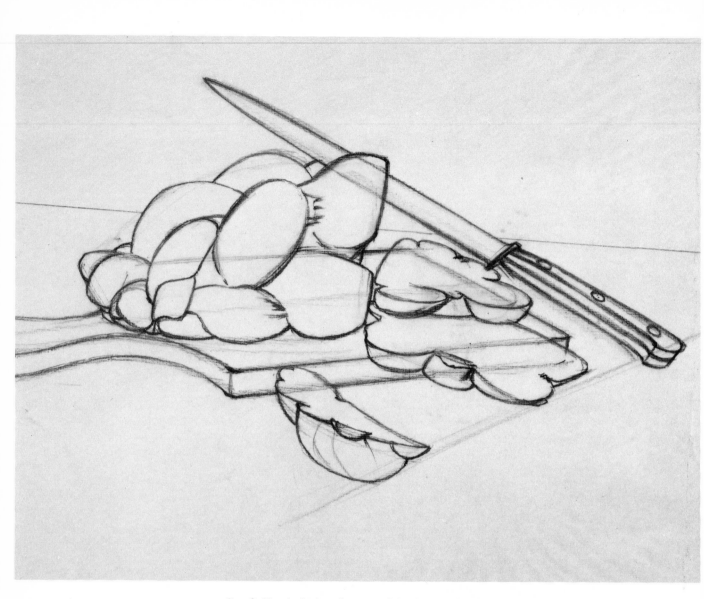

Step 2. *Here's the line drawing of the sketch I finally selected for the egg tempera painting. Notice how the new bread knife integrates itself much more rhythmically with the other elements in the picture. I use an office pencil to establish definite contours and construction, and decide that an area 12½″ x 9½″ will frame up the objects in the most pleasing manner. This will still leave a generous border around the picture once I transfer it to the 16″ x 13″ Presdwood panel I've prepared for the finished painting. I'm considering a checked tablecloth on the table at this stage but I decide not to impose such a painstaking job on you. However, if such a tablecloth holds no terrors to your industry and diligence, please feel free to add it.*

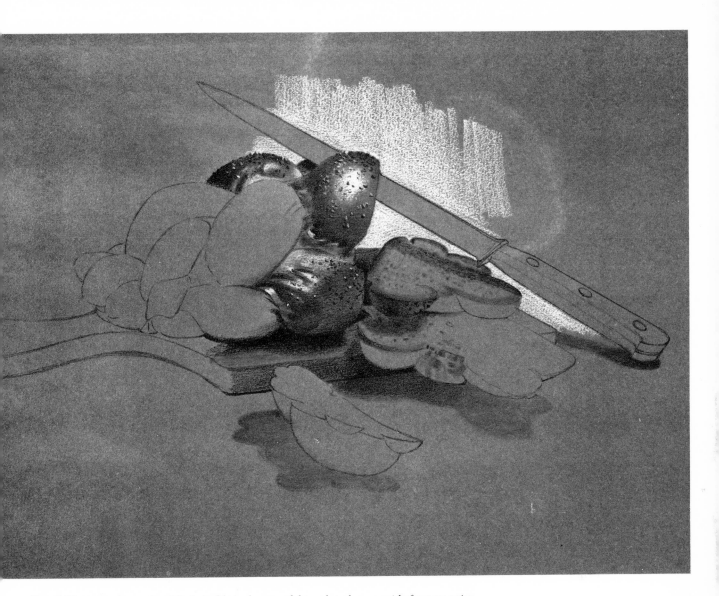

Step 3. There are times when it's desirable to do a careful tonal study as a guide for your painting. I trace the line drawing from Step 2 onto the charcoal paper with a black pastel transfer paper. I do this so that the carbon pencils I'll use later for rendering won't skip, the way they would over a line traced with customary ("lead") graphite transfer paper. I start to indicate the darkest dark under the bread and go on to the lighter tones on the bread itself, rubbing them with a paper stump. I pick up lights with a kneaded eraser and establish highlights with white Conté. When my drawing is finished, I decide that the buff color of the charcoal paper itself would make a nice table top in the tempera painting, with a light gray wall for the background.

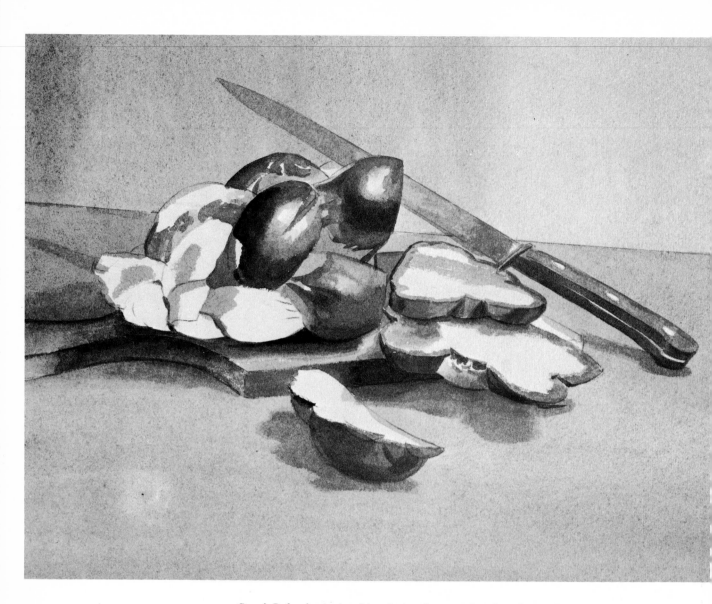

Step 4. *Before beginning this painting, I give my Presdwood panel four coats of Liquitex gesso with the 2″ brush and sand each coat before applying the next one. I arrange the burnt sienna, burnt umber, yellow ochre, black, and white egg tempera in their individual saucers on the butcher's tray. Then I mix a puddle of very thin umber and black with a great amount of water, and float in the background with the #5 and #7 watercolor brush. I take these washes right across into the drawing of the knife, and slightly into the bread and the table. Next I lay in the table itself with a wash of burnt sienna and burnt umber, again going slightly into the other elements. Then I begin, still with thin washes, the definition of the bread, the knife, and the bread board.*

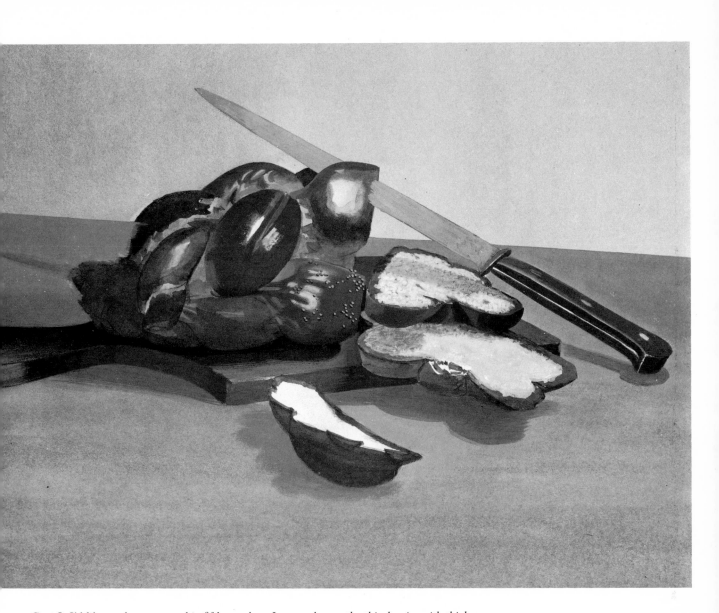

Step 5. *I'd like to show you at this fifth step how I proceed, over the thin lay-in, with thicker pigment and begin rendering the various areas. I've gone over the blade of the bread knife using mostly white and black, tempered with burnt umber, and work slightly into the bread itself. I've also begun to bring out the detail of the handle. I carry everything to a stage of near completion, but don't complete any object yet. With burnt sienna, yellow ochre, and white I begin to define the bread, creating highlights by wiping off paint with a clean rag. I'll refine these highlights later and I'll explain why in the next and final step. I've completely finished a portion of the loaf (lower right corner) including even the seeds, only to demonstrate the sequence in painting: On the bread board I use drybrush to create its wood textures and refine its light and shadow pattern. Then I tackle the slices using the point of the #3 brush with thick pigment on the light areas. For the bread's crust, I glaze thin washes of burnt sienna and yellow ochre.*

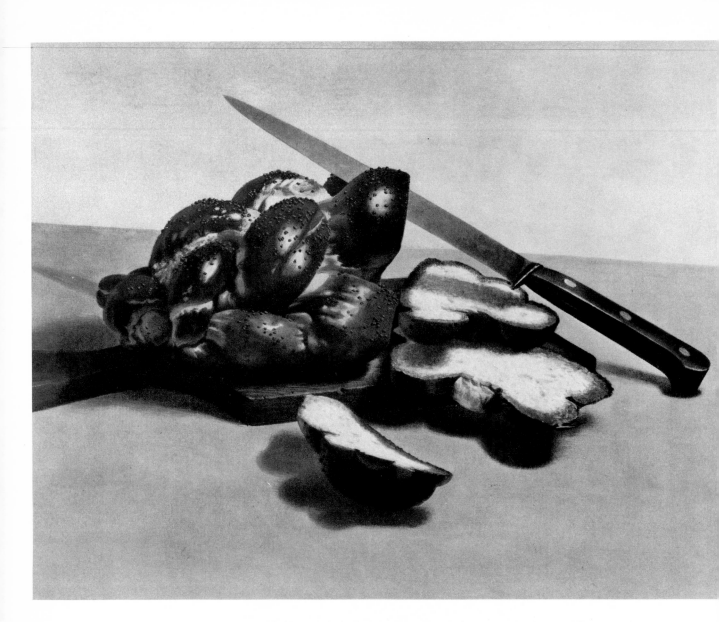

Step 6. *Now, with thicker pigment, I work from the back forward: first I do the gray wall, brushing it slightly into the table, the knife, and part of the loaf. Then I deepen the values on the entire painting with thin washes and also thicker pigment as it's needed. I define highlights on the bread with a light value because it will give me better shapes than working around these highlights with darker tones. Some artists use the heel of the brush for the straight lines like those on the knife, but I prefer to employ the point of the brush, using the ruling method that I described in Project 5. I use the #7 brush for the large flat areas of the background and the table, working it back and forth to spread the pigment evenly. If the application of paint turns out to be thin, give the areas another coat. Remember that the minutest details come last. Here, the final touches are the seeds on the bread.*

Graded Wash in Egg Tempera

I begin this demonstration with a pencil sketch. To the sketch I add notes about the color scheme of the scene so that I can refer to them once I'm back in my studio. For this egg tempera painting, I use a variety of techniques. One of these is a graded wash. To float a graded wash in egg tempera you use different methods than those you use with opaque watercolor or acrylic. You'll see me use one of these in the demonstration.

In this demonstration painting you'll also see me use a razor blade to make incisions to simulate grass and peeling plaster and paint. In addition to razor blades, you'll need a sketching pad and a 20″ x 15″ piece of hot pressed (that is, with a smooth finish) illustration board. I use Crescent #115 illustration board. You also need a #314 draughting pencil, #3, #5, and #7 watercolor brushes and India ink. Besides fresh yolks, you'll need the following palette of dry pigments: burnt sienna, yellow ochre, ultramarine blue, black, and white.

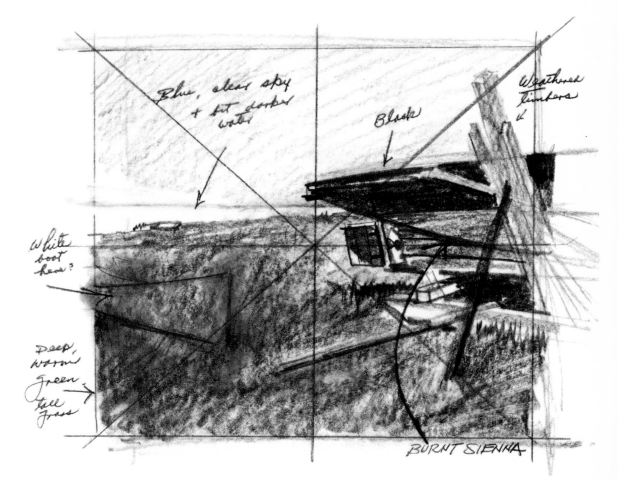

Step 1. *Usually I sketch a motif in its entirety, and then later in the studio when I work on the composition, I may shift it about or crop it. But in this sketch I wanted the excitement of lines and shapes from the very beginning. So I brought my old faithful #524 tracing pad from the car and did this rough on the spot with the draughting #314 pencil. Then I wrote color notations on the margin of the sketch. The X and the cross you see on it were done later in the studio to enlarge it for the color sketch and the painting. This project is to demonstrate the simplest means of sketching, but let me add straightaway that quick as it is, it approaches nature no less reverently than when equipped to the teeth to record her minutest detail.*

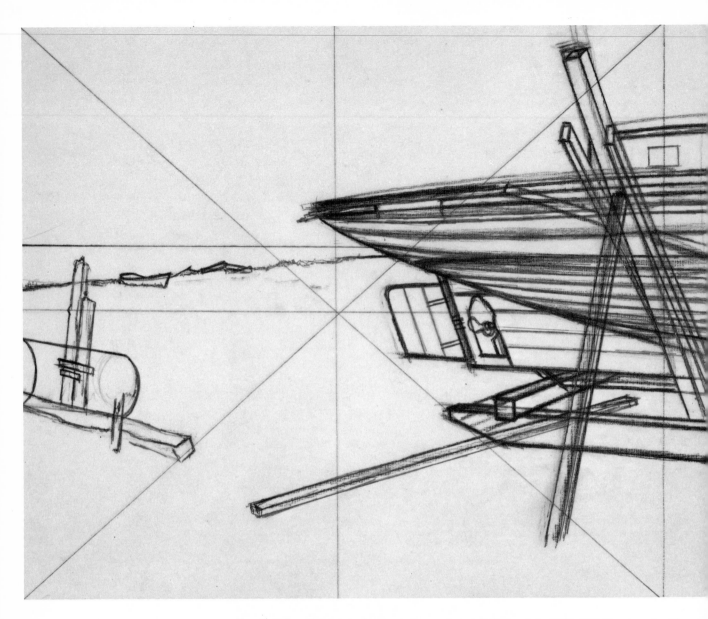

Step 2. *This enlargement, in proportion to the original sketch is 10½"x8½". I've done it with the office pencil on another piece of tracing paper, and have added the old rusty tank on the left to counterbalance the boat and the timbers on the right. I'm not sure, however, that I will retain it for the finish. After all, it was the disposition of the shapes that prompted me to record the scene in the first place. I haven't indicated the grass because I know I shall develop it gradually both in color and texture in the next stage. As I mentioned previously, I have all the information I need about grass in my sketch bin. Of course, I could have rendered the grass from memory and imagination, but I'd run the risk of stereotyping it.*

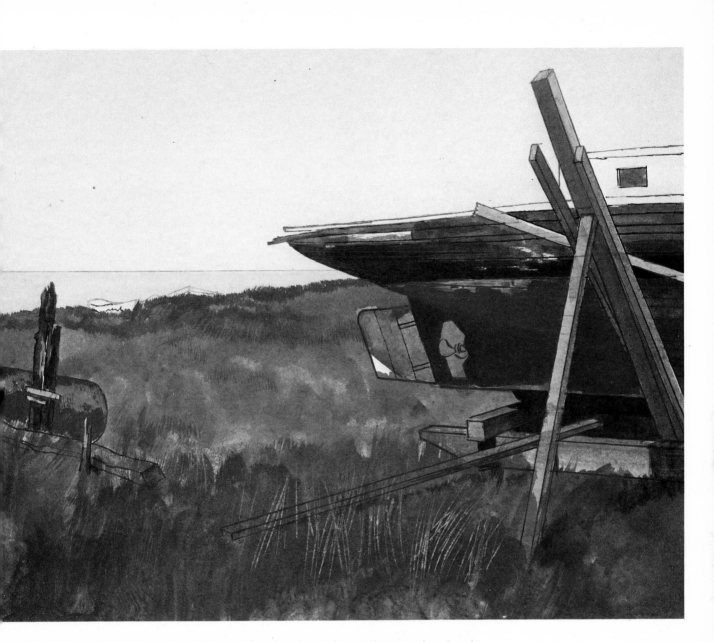

Step 3. *Between the last step and now, I've transferred my drawing to my illustration board, and reinforced my line drawing with pen and ink. I begin here to apply thin color on every area of the picture, including the sky. I paint the sky by first turning the drawing upside down. I prepare a large puddle of mostly white with a touch of ultramarine blue, and begin painting at the horizon patting with the side of the fully loaded #7 brush right across the horizon. Then I recharge the brush, again generously, and repeat the process working quickly so that the preceding band of color will still be wet and spread evenly into the succeeding one. As I near the bottom of the board (which will be the top of the sky), I add another touch of blue to the puddle on the tray. Then I turn the picture right side up and apply a mixture of yellow ochre, blue, and a touch of burnt sienna to the grass area, and the same mixture on the timbers. I use black with a touch of blue on the boat, and burnt sienna below the water line and on the rusty tank.*

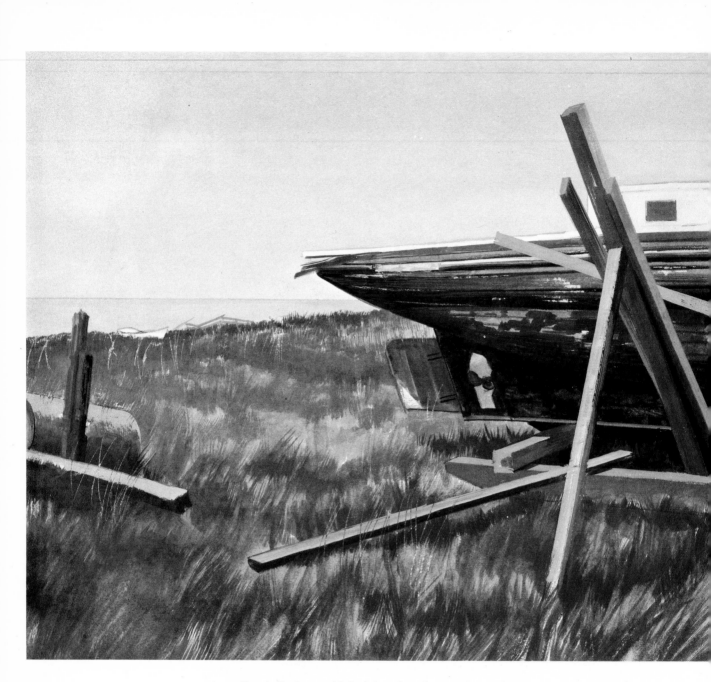

Step 4. *Having established the color scheme in Step 3, I start to articulate and define textures and details with the #3 and the #5 brush and thicker paint. I begin at the edge of the grass in the middle distance and work my way forward, slightly overlapping the grass into the boat, the tank, and over the timbers on the ground. Some of the long, light leaves of grass are incisions done with the corner of the razor blade down to the bare board, as are the white spots on the hull. Still working forward, I tackle the entire boat, adding white as well as black to the burnt sienna to bring out the form of the hull and to do the oil stains on the keel. Then, deciding to keep it, I lighten the rusty tank so it wouldn't clamor for attention. I move to the timbers and give them definite lights and shadows in flat tones so that later I can add textures on top with drybrush.*

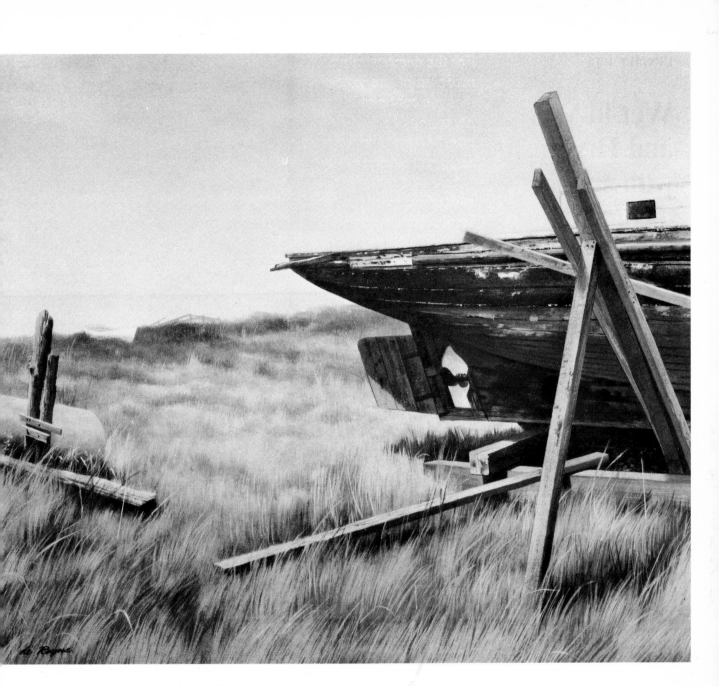

Step 5. *I've mentioned that there's hardly anything so delightful as reaching the final stage in a painting. Now, to the last refinements on this job. Using the razor blade I continue making incisions on the boat and on the grass, especially the grass in the distance close to shore. Then I paint the textures on the boat's cradle and on the rudder, using the drybrush technique. Most of the grass in the foreground is done with the tip of the #3 brush, but the leaves bending across are incisions made with the corner of the razor blade.*

Wet-in-Wet and Drybrush with Egg Tempera

For the demonstration in this project I've decided to paint a still life made up of the various materials and tools in my studio. I suggest that you continue to use your taboret for working, and place your still life on top of a black mat board on another table. For this demonstration, be sure to have a second set of tools so that you won't disturb the arrangement of those you're painting.

In the demonstration of this painting, I use techniques on opposite ends of the paint consistency spectrum: wet-in-wet blending and drybrush. You'll see me using wet-in-wet blending on the cup and saucer and the butcher's tray. The drybrush is most noticeable on the water jar.

For this project you'll need the following surfaces: a sketching pad, a tracing pad, and a 30″ x 15″ piece of illustration board for your final egg tempera painting. Again I use an Ad Art pad #307 for sketching and Crescent brand illustration board. In addition, you'll need your three pointed watercolor brushes and the #20 square sable. Along with fresh egg yolks, you'll use the following palette of dry pigments: American vermilion, yellow ochre, ultramarine blue, titanium white, and ivory black.

Step 1. When I "took five" and started sipping my coffee, I wondered why I hadn't noticed before that the stuff on my taboret made rather a nice motif. Probably because I'd had it for years under my nose, and, to twist an aphorism, "familiarity breeds blindness." Anyway, having reached an intermission on another painting I was doing, I picked up my #314 draughting pencil and the #307 Ad Art pad and made this quick sketch—leaving out many extra tools and paraphernalia. Perhaps it looks a bit clinical now, and rather fraudulent, but I thought I'd better do away with the actual clutter. When the sketch is complete, I decide to go ahead and do a painting of it, so I throw the grid on it for future enlargement, and "fix" it. The sketch measures 7″ x 6¼″.

Step 2. *This is the working drawing with the squaring-off grid on it. I know you can't see it because I used a light blue pencil that I know doesn't photograph in a black and white. At this stage I'm only concerned with the correct construction of the elements. Notice that I've "drawn through" every object to set it in its proper perspective. I must mention once more that you must know how to draw before you tackle the problem of how to paint.*

Step 3. *You can, of course, begin a painting right on the final support, beginning with tentative sketches, refining the drawing, and then securing it gradually with more substantial media as the work progresses. My intention here, in separating each step, is to make it easier for you to concentrate on each phase separately and to deal with one problem at a time. Here I trace the drawing from the previous step onto my piece of illustration board. Then I mix up my paint, adding yolk to the dry pigments and mixing each color in a separate china bowl. Then I start the lay-in with thin washes.*

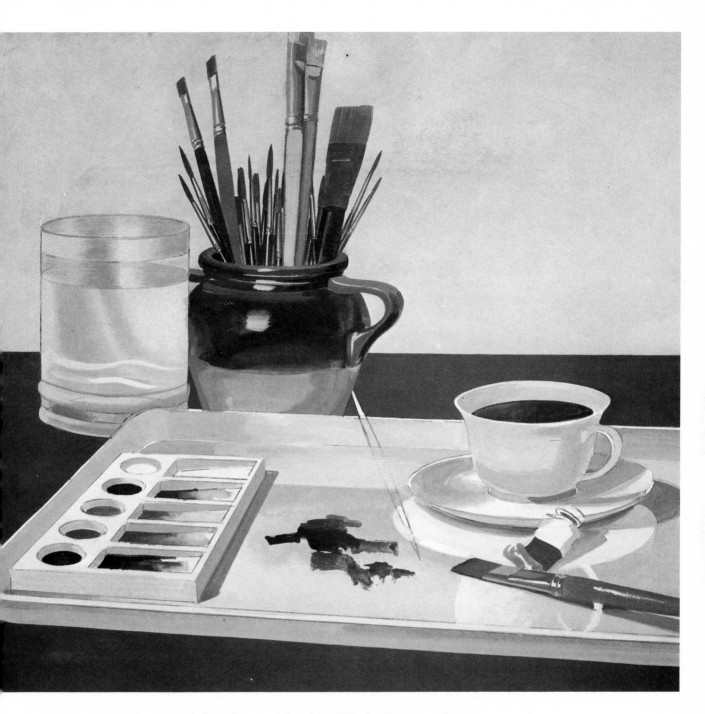

Step 4. *I've set up a (100-watt) spotlight at the upper left of the still life that I've arranged on a small table to the left of my taboret. Then I start refining and developing the washes I've indicated in the previous step. I first paint all the brushes. I drybrush further definitions on the water jar, work on the cup and saucer, fill the palette with color, and carry to semi-completion the tube of paint and the square #20 brush. I'm still using thin pigment I keep a sharp eye on the warm whites (white and yellow ochre) of the cup and the palette, as compared with the bluish cool whites of the tray and the water jar. I'm using my three watercolor brushes and the square sable. I thrust them deep into the china dishes to pick up paint. The coffee is "black," the tube of paint is yellow ochre, and the handle of the #20 brush on the tray is light, natural wood.*

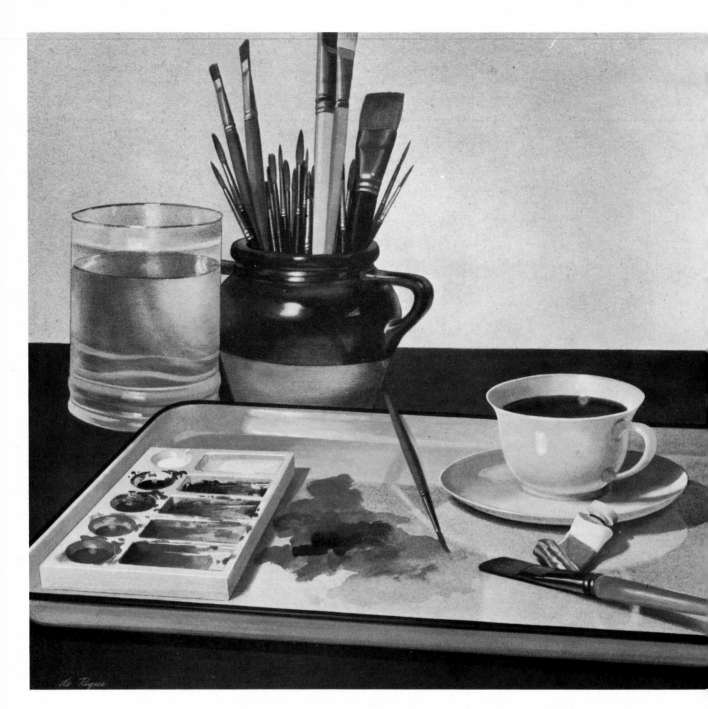

Step 5. *First thing I do here is to smooth out the background. I've considered a rough surface to contrast with the smooth textures of the elements. The background is a smooth flat, light gray that's actually on my studio walls. I feel that the visual texture created by my brushes needs no further texture behind them. Working my way forward I finish with drybrush over the indications previously done, the water jar and the brush pot. The white sparkles on the jar, and the highlights on the brown of the pot are, of course, painted with wet, thicker pigment, as are those on the ferrules of the brushes. Now I must ask you once more to practice the ruling method. I use it on the tray, the palette, and even on the brush handles. It would have been torture to render all these straight edges freehand. I've gone over the palette in my painting with a warm white (white pigment with a spot of yellow ochre) so that the pure whites I want to use for highlights will show up. Following the spots and spatter on a palette I'd used, I render similar ones on the palette in the picture.*

PROJECT 16

Scraping and Egg Tempera

In addition to illustration board you'll need a sketch pad and tracing paper. I again use my old faithful Aquabee tracing pad #524, an 11″ x 14″ Ad Art pad #307. You'll also need a draughting pencil #314, a grade 2 office pencil, and a 5H pencil for tracing. For the egg tempera painting you'll need your regular assortment of boards, razor blades, egg yolks, as well as yellow ochre, black, and white dry pigments.

A razor blade can be an invaluable tool. With it you can execute an intricate subject that would take a prohibitive amount of time if you were to render it in the orthodox manner with a brush. However, before you scrape, you must prepare your board. Be sure that your surface is sturdy enough to take the punishment of the razor blade. You must be able to scrape with your blade without digging past the surface paper. The board I have suggested is Crescent illustration board #115, hot pressed. It has a Strathmore 100% rag watercolor paper as a surface. This paper is tough enough to take the rough treatment this technique requires. The scraping technique is not only efficient but fun! But beware. The incisions left by a razor blade can give a cold and mechanical look if you overdo them.

Step 1. *It is my good fortune to live in a part of the country where trees abound. I found this one not five minutes away from home. It's not really a beautiful tree, but it has such character that I just can't resist it. I think that the main thing that attracts me to it, however, is the mood created by the abandoned swing. I've done this sketch on my #524 tracing pad with the #314 draughting pencil, using the side of the lead for broad strokes; these cover an area in the quickest possible time. I include as much of the scene as possible, since I can always easily crop the composition back at the studio. I don't indicate the leaves on the ground because I know that my own yard is covered with the same type, and I could do them back home.*

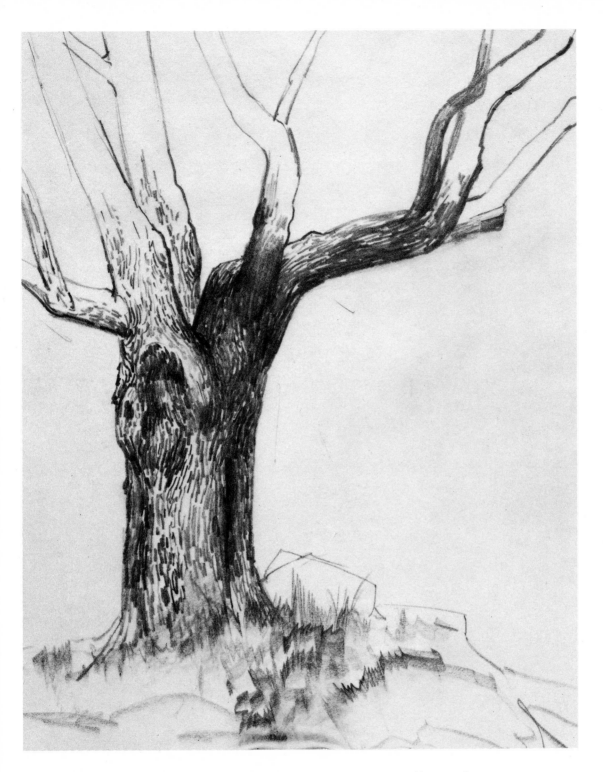

Step 2. *After I finish and fix my drawing, I place a sheet of tracing paper over it and begin, with an office pencil, to refine contours and add definition to the bark. Notice especially the rhythms of the bark as it ascends from the base of the trunk, and the configurations the bark makes as it meets and swerves into the branches. What you see here is the careful study of the tree, complete with every bit of information that I need. As I work on this study, I try to retain the mood of the first impression that lured me to the subject.*

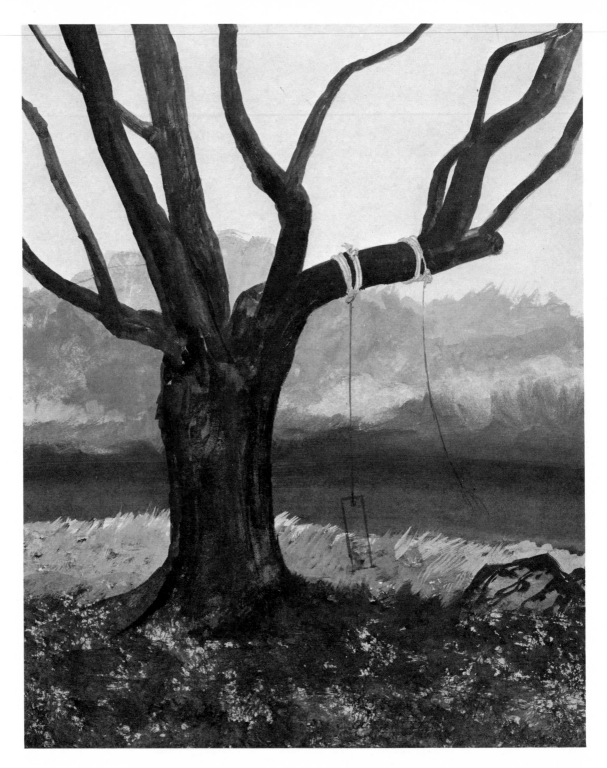

Step 3. *I've traced my pencil study to the illustration board, using the 5H pencil. Notice that instead of cropping, I've kept the larger size shown in Step 1, which is 8½″ x 10½″ because I felt the smaller dimensions really crowded my subject. The yellow ochre, the black, and the white egg tempera paint is arranged in separate containers on my butcher's tray, and I'm ready to begin painting. Using the #20 flat sable I give the sky a very thin coat of yellow ochre, mixed with a touch of black, and much white. I apply paint with horizontal strokes. I work the sky into the edge of the background, and right across the top part of the tree. If a branch or any detail threatens to get lost, I reinforce it with the office pencil. Then I indicate the middle distance and the stream in a very broad manner. I use the same three colors that I used for the sky. For the foreground I use very thin black and apply it with a sponge. Then I glaze the foreground (after it's dried) with a thin layer of yellow ochre. Finally I delineate the shape of the tree, again with mostly black thin paint.*

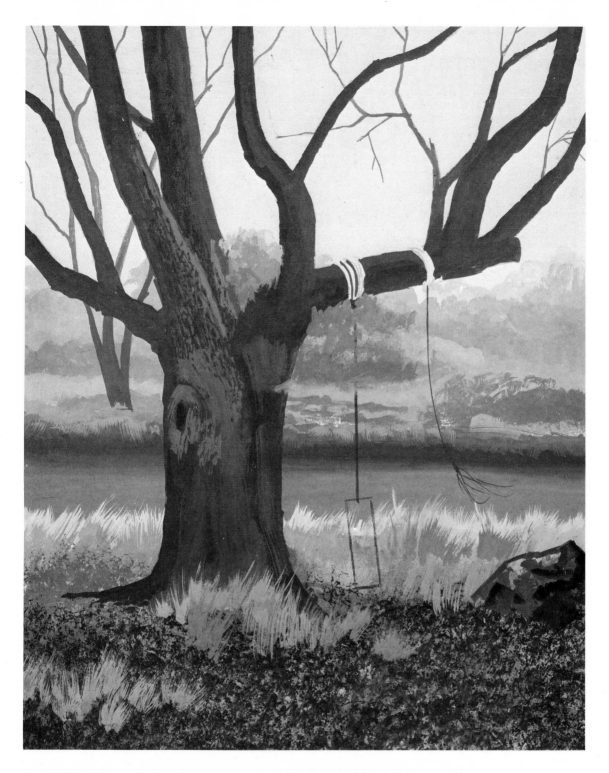

Step 4. *When Step 3 is finished, I compare my lay-in with my original sketch. I notice that the smaller bare trees on the left enhance the composition. The pattern of their branches, combined with those of the foreground tree, soften the stark look in this area of the painting. So I introduce one tree, as you see it here, and add a few twigs on the main tree for balance. Again, working from the back forward, I paint the band of trees and bushes, using the heel of my #5 brush, and even my finger to soften some edges. After carefully checking my pencil study, I start to indicate the bark of the tree using lighter and darker pigment as needed. I develop the bark just enough to give me an idea of how its texture will work against the soft trees behind it. As you know by this time, the woods in the distance must be finished before the large tree in front. As I paint across the swing, I'm in danger of losing it, so I reinforce it with an office pencil.*

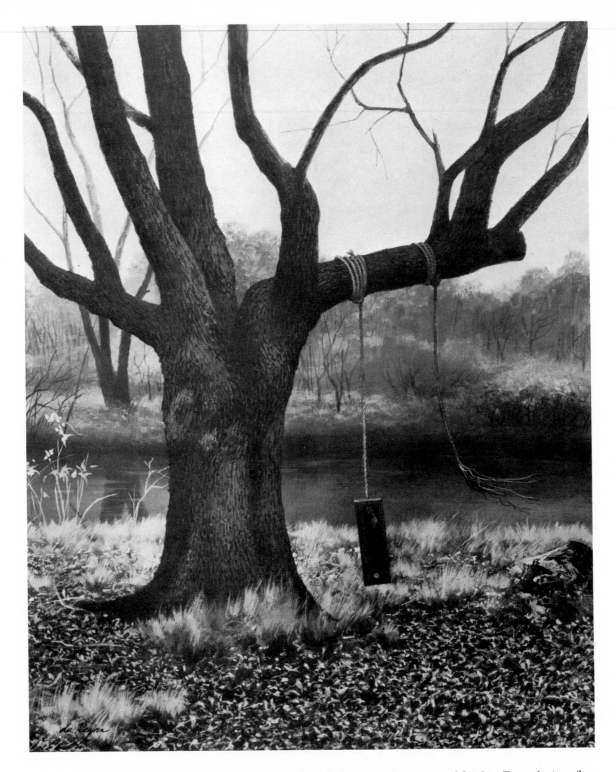

Step 5. *After I render the distant woods, I move to the stream and finish it. To render its reflections, I work wet-into-wet with the #5 brush. Then I shift to the foreground. With upward flicks of the #3 brush I regain the edge of the grass on the near bank. Now I start to incise scrape the leaves with the corner of the razor blade. I scrape all of the little shapes in various directions. Then, over the scrapings, I apply darker glazings and tints. With the #2 brush I actually define a few leaves wherever the texture made by the knife threatens to become monotonous. Notice the character of the leaves now, compared with only the sponging that I used on them in the previous step. Even here, if any area starts to look only like scraping, and not leaves, I instantly restore it by modifying the edges of the incision with a brush. The swing comes next, then the weeds on the left. Finally, I give the grass in the foreground its last touches, and bring out the texture on the rock.*

Glazing, Scumbling, and Sponging with Egg Tempera

In this project I combine a variety of techniques—glazing, sponging, and scumbling on a tinted mat board; in this case it's tan. You'll see me utilize all three techniques to achieve a diversity of textures and tonal values. In the composition of this demonstration painting, perspective plays a large part. That's why it's important to get your preliminary drawing correct and solve perspective problems, so that you can then concentrate on manipulating the egg tempera medium.

In addition to the 16″ x 20″ piece tan mat board for your final painting, you'll need an 11″ x 14″ Aquabee sketching pad, and a 16″ x 20″ tracing pad. For the preliminary color sketch, you'll need opaque watercolors (I, again, use Marabu watercolors and Artone white), along with #3, #5, and #7 watercolor brushes. For the egg tempera painting you'll need the following palette of dry pigments: titanium white, ivory black, and yellow ochre—a limited palette, as you can see.

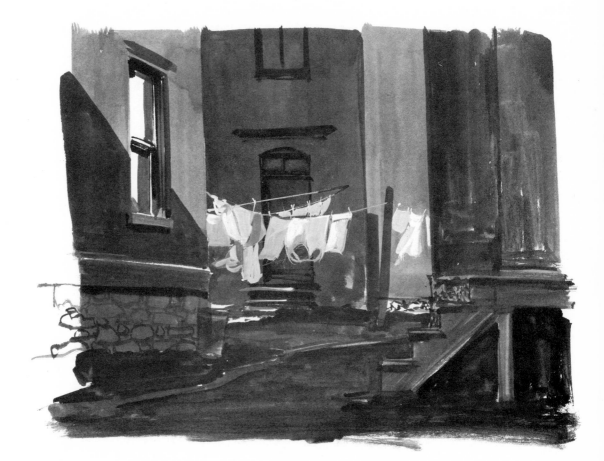

Step 1. *For this sketch I use an 11″ x 14″ Aquabee #664H pad, Marabu opaque watercolors, and a #5 watercolor brush. While I work, I keep referring to the imaginary eye level which I've placed just about on the top step under the clothesline. The light shapes on the buildings are done in yellow ochre with a bit of black to kill the yellow's glare. I paint the dark shapes in diluted black with a touch of yellow ochre. Everything in this sketch I paint with thin washes of color, except the clothesline. For it I use pure white thick enough to cover, and dip into the black to show the shadows of folds. This sketch is roughly 9″ x 7½″.*

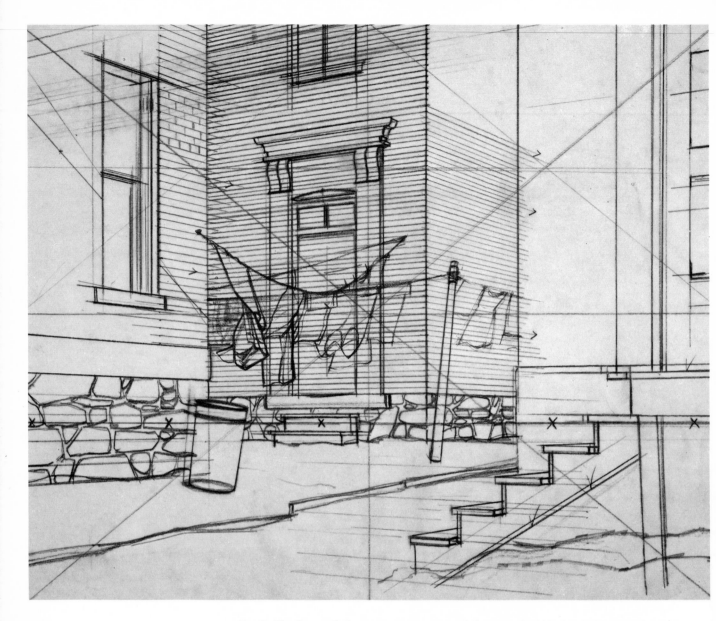

Step 2. *The diagonals from corner to corner and the vertical and horizontal lines at the center are merely the lines I've used to enlarge the sketch to 13¾" x 11". As I've mentioned, drawing plays a vital part in the technique I'm demonstrating here. I mentioned in Step 1 that I guessed the eye level to be in line with the top step under the clothesline. In "trueing up" my drawing, as you see, the eye level falls just a fraction below that step. I've marked the eye level with an X so you can spot it quickly. All the lines slanting downward toward the right (on the building at the left and on the building in the center) converge at a vanishing point—on the eye level—outside the picture area. The vanishing point at the left (also outside the picture area) serves as the converging, or vanishing point for the lines on the face of the center building.*

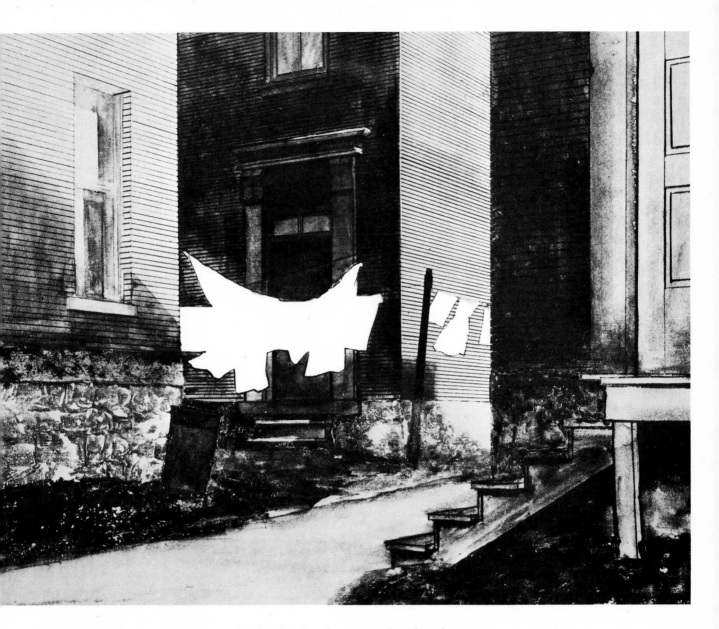

Step 3. *I didn't indicate any bricks on my sketch in Step 1, so I now count them from the top to the bottom of the window at the left. There are thirty-nine. When I enlarged the drawing in Step 2 all I did was to allot 39 bricks to the window and carry the converging lines over to the side of the center building. Here, I trace everything from Step 2 except the converging lines of the bricks. These I render with an office pencil, pressing hard, right on the tan mat board which I'm using as a surface for my egg tempera painting. I follow only the points of departure that I traced on the window and the corner of the center building. Then I start to paint in the first thin layers with the #7 brush. I skirt the contour of the clothes on the line. With thick pigment I indicate the rock foundations of the buildings. For the area under the stairs and across the passageway, I apply thin paint with a piece of sponge.*

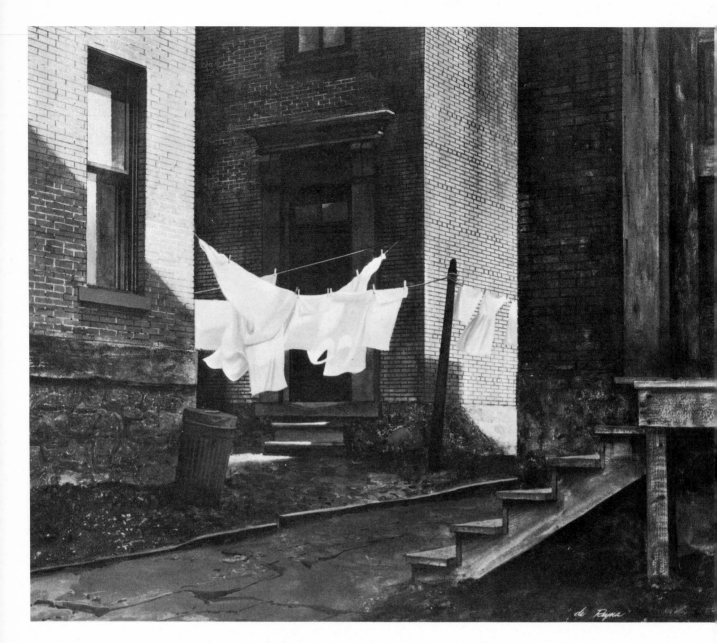

Step 4. *While I've done the horizontal lines on the bricks in the previous step, I've yet to do the staggered vertical divisions in relation to the length of the standard brick. When I counted thirty-nine bricks as the height of the window, I also made a notation (on the margin of the sketch) that there were three bricks, lengthwise, between the window on the left and the corner of the building. All the dark lines that you see here I've done with my office pencil. They show through the thin washes of yellow ochre and black. I've gone over some of them with light-colored thick pigment—on the face of the center building and on the left one—because those bricks were replastered. These "replastered" bricks serve to avoid the monotony of the dark lines. Then I go over the clothes on the line, softening edges and defining folds. With the #3 brush I add texture to the stairs and the door on the right with drybrush. With the ruling method, I throw in the light clothesline across the dark door. The clothespins and the stain (thin wash) on the center brick wall are the last things I render.*

PROJECT 18

Working with Casein

Now you're going to try your hand at painting with casein. Casein paints are *not* opaque watercolors. That is, they have completely different characteristics that should be played up to their full advantage to bring out and emphasize their "painty" quality. For example, you can create (not just delineate) texture with them. You can use casein thickly to produce a lovely impasto—good for simulating rocks, walls, or any rough texture.

Besides trying your hand at casein handling in the preliminary sketch of this demonstration, you'll also use a sponge to depict melting snow. It's a good idea to get a brand new sponge for this particular job. I got a 3½″ x 6″ one from the supermarket and cut it with a mat knife into four equal parts. Each piece is then just the right size for easy manipulation.

You'll need the following surfaces for this demonstration: a watercolor pad, a 15″ x 15″ piece of illustration board, double thickness, with a hot-pressed surface. I use an 11″ x 15″ pad of Watchung watercolor pad and Bainbridge illustration board #172. Prismacolor black pencil #935, and office pencil, and a 5H pencil for tracing are needed for sketching. For the final casein painting, you'll need the following palette: Venetian red, Shiva green, ultramarine blue, yellow ochre, and black, and white. In addition, you'll use opaque watercolors plus #3 and #5 watercolor brushes, a synthetic sponge, and Silicoil brush cleaning fluid.

I should caution you now to separate whatever brushes you'll use for casein from the rest of your stock. The reason is that the casein-filled brushes must be washed in mild soap and water, not just at the end of the day's session, but *as you work*! Even when you rinse your brushes as you change from one color to another, the milky binder of casein sticks to the brushes. Before long they lose their maneuverability. So, as I work, after rinsing out the paint, I rub my brush gently on a bar of Ivory soap and rinse it again.

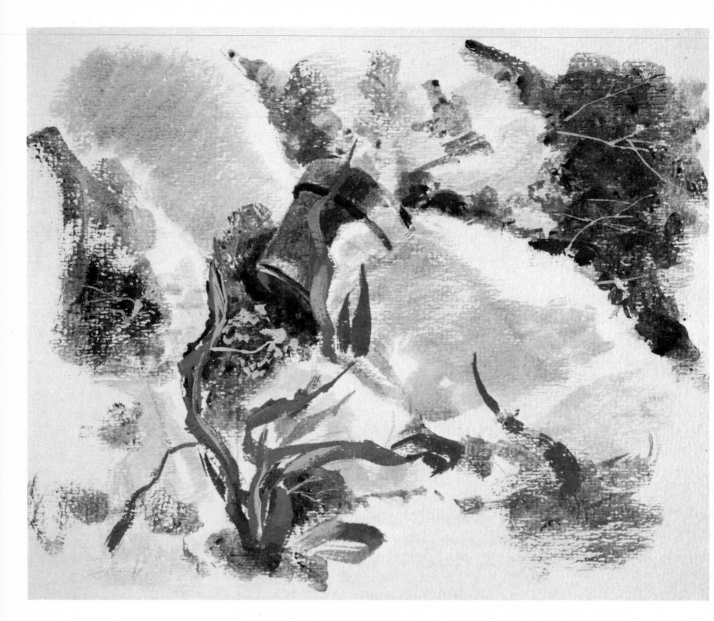

Step 1. *It had snowed the night before and the next day was warm and clear. I'm sure that most of you have seen the beautiful patterns that melting snow can make, especially when some of it remains through another cold night and crystallizes into lacey edges. Such edges caught my eye in this scene. One flower pot had not been put away the previous fall, and here it was among the irises. I use my Watchung pad, casein paints, and a #5 brush. I use this paper because its rough surface gives me the sparkle I want to carry over to the finished painting. I use Venetian red and black casein for the pot, ultramarine blue for the snow, and black for the wet ground. The whites are provided by the bare paper. I paint everything in thin washes; the only thick pigment is on the plant.*

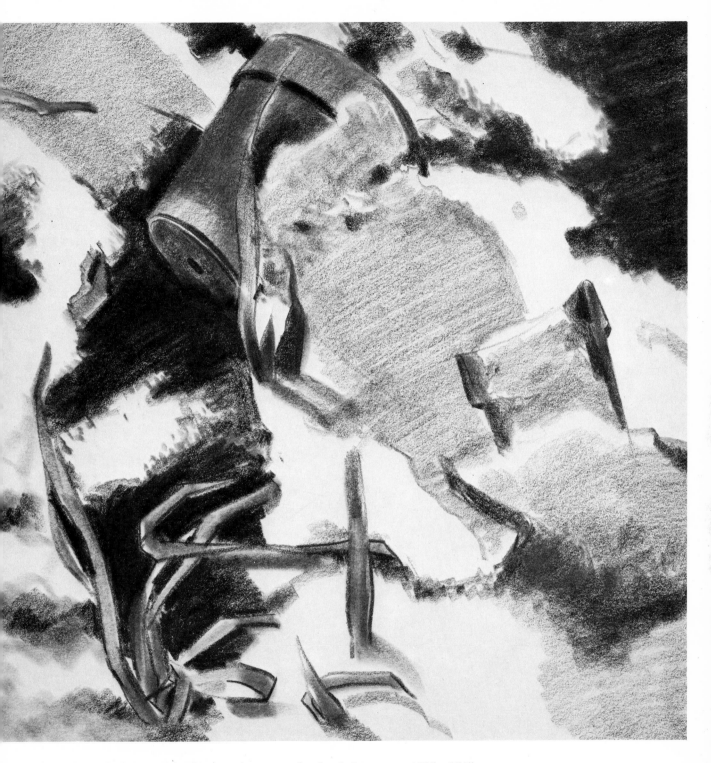

Step 2. *This is the drawing I develop from the casein color sketch. It measures 10¼″ x 10¼″. I've done it on the 664H Aquabee pad with a #935 Prismacolor pencil. My main purpose here is to arrange the whites, grays, and blacks—the tonal values—to achieve the best composition. The great advantage of using the Prismacolor pencil is that it doesn't smudge. When you rub it with a paper stump dipped in Silicoil brush-cleaning fluid, this pencil produces blacks that are as rich as those produced from India ink. I'm sure you've noticed that, to balance the large pot, I introduce the remnants of a smaller one.*

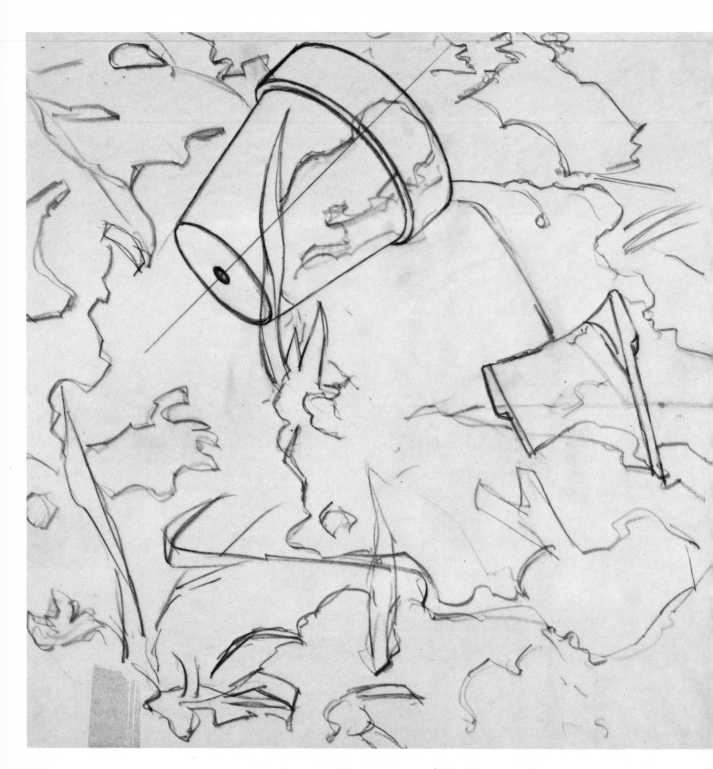

Step 3. *After tracing the main shapes on to my illustration board, I can easily see the rhythm and movement of the lines. I then go over the lines with my office pencil to make them dark enough so that when I start painting they won't get lost. Notice I've drawn the entire pot—even though it will be mostly covered by the snow later—because it's the only way to assure its cylindrical symmetry. Now I'm ready to paint. I've moistened the burnt sienna, Indian red, ultramarine blue, yellow ochre, and French green in my Marabu opaque watercolor box, and set up on the butcher's tray extra black and the white opaques (Artone brand). I have also two big water jars and two pieces of sponge: one for pure whites, and another for color. For quick reference I move the flower pots right into my studio.*

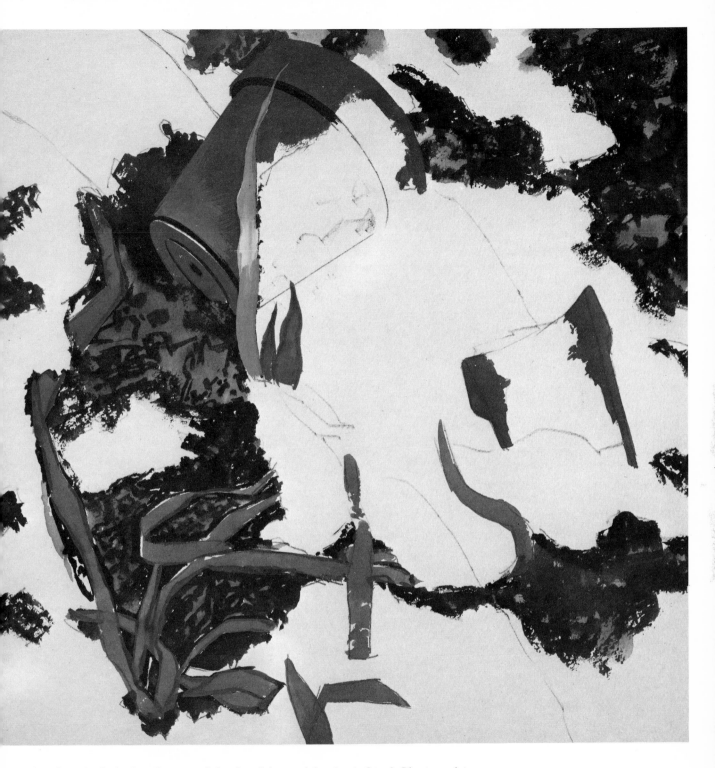

Step 4. *As I refer back to the original sketch and the tonal drawing in Step 2, I begin applying the dark shapes and texture of the ground with the #5 brush. For these, I dip mostly into black, but also into the burnt umber, to convey the wet and soggy ground still strewn with the remnants of autumn's leaves. I flick the brush about with the point and the side, watching for evolving shapes that I may want to emphasize later. I'm not yet concerned with the character of the edges of the snow; I just want to set down the dark and light abstract pattern of the composition that I've arranged in the pencil drawing. This includes the sickly greens of the limp leaves of the iris. For these I use French green, yellow ochre, a touch of Indian red, black, and white. Then I work on the pot with red, black, and white.*

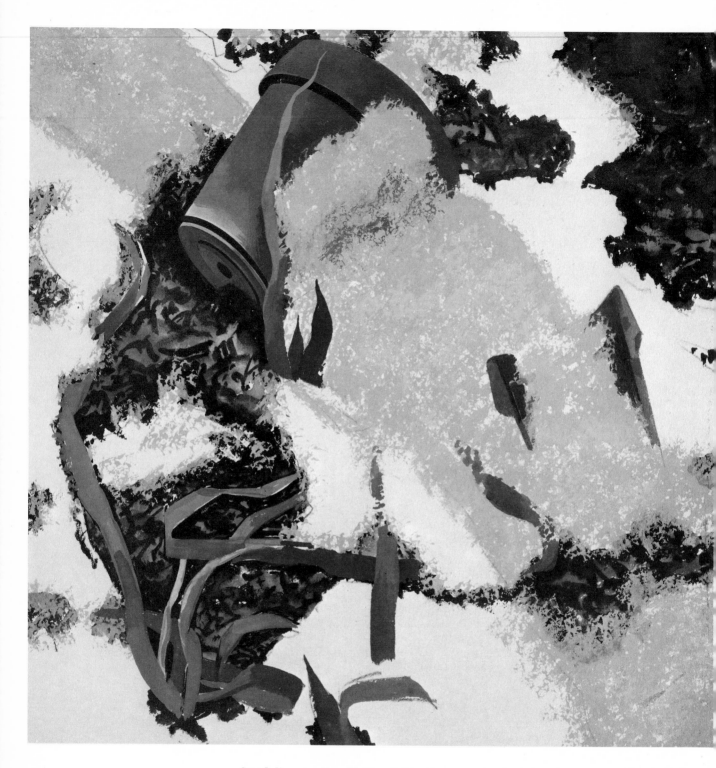

Step 5. *I've mixed in a 3″ china dish (so I can cover it to keep the color moist) a cool, light blue. To create it I use much white, a bit of ultramarine blue, and a whisper of burnt sienna to kill its raw pastel tint. I test this color on a piece of scrap paper to check the value of it after it's dried. It's exactly what I want, so I dip the entire piece of sponge in the water jar and squeeze it damp. Then I transfer, with the #7 brush, some of the blue in the dish to the tray, where I dilute it to the right thin consistency. Then, holding the damp sponge, bent in half, between thumb and two fingers, I tap the curved side on the puddle of pigment; then I tap the sponge on the diagonal shadow you see here from upper left to lower right. I tap it all along that line to suggest the edges of the melting snow.*

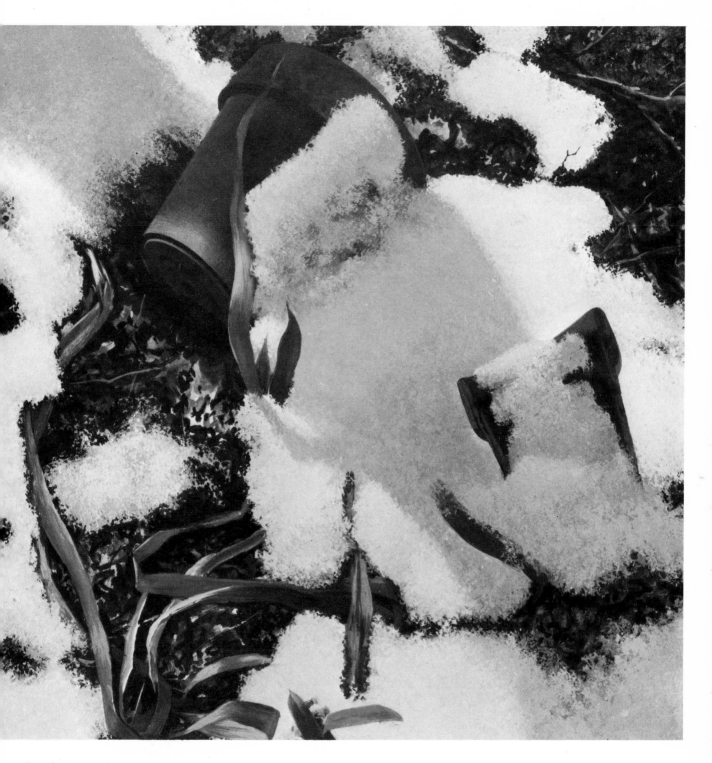

Step 6. *Here I go back to the ground and apply thin washes of yellow ochre, black, and whispers of ultramarine blue to create the light grays that I need to depict some of the dead leaves. I finish the ground completely. Where necessary, I work the ground slightly into the edges of the snow, since these edges will be re-defined later. Then I mix another batch of color—mostly white with a smidgeon of the blue—for the shadows on the snow, but this time I add yellow ochre to "warm it up." I'll use this same color for the areas of snow that are in the sunlight, because they should be warm in order to contrast with the cool, bluish shadows. I soften the shadow edges as I work using two sponges; I use one for the lighter value which I work into the deeper tone of the shadows and vice-versa. Then, using drybrush over what I previously laid in wet-in-wet, I render the spots and stains on the pots. Notice that the diagonal shadow is lighter and darker as it dips and rises. The point I want you to remember is that shadows are not one even flat tone.*

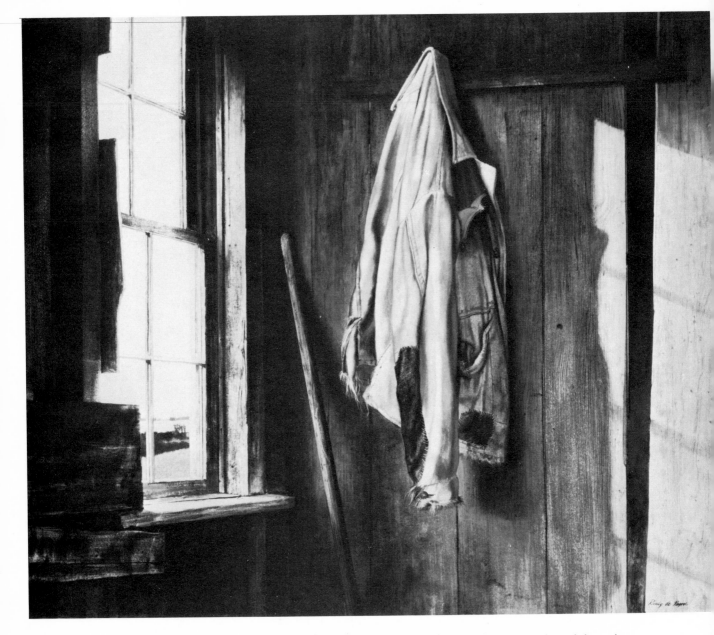

Joe's Jacket. 20″ x 24″. Egg tempera on mat board. Collection of the artist.

Color Demonstrations

Multiple Textures with Acrylic

These last eight projects are reproduced in full color. In these projects I'll concentrate on those specific problems that the use of color introduces: selecting a color scheme, controlling values, and manipulating warm and cool tones.

In addition, in this demonstration you'll put to work what you've learned about impasto, glazing, stippling, and drybrush to help you create a variety of textures. You'll be working with acrylic and you'll need the following acrylic palette: Hooker's green, burnt sienna, cerulean blue, ultramarine blue, acra red, red oxide, burnt umber, yellow ochre, Mars black, and titanium white. In addition, you'll use an 11″ x 14″ pad (I've used an Aquabee #1171) and a #6 flat bristle, #4 bright bristle; #20 flat red sable, and #3 and #5 pointed red sable watercolor brushes. Finally, you'll want a painting knife, a sponge, and a 20″ x 30″ piece of plate finish, double thickness illustration board.

If you wish, you can work smaller than 20″ x 30″ on a single thickness (roughly 1/16″) say 15″ x 20″. However, a single thickness 20″ x 30″ board would buckle slightly, so stay with double thickness in this larger size. There may be areas where your subject may suggest a scumble technique to achieve the desired texture. With a sponge or with a bristle brush vigorously pre-coat these areas with a thin layer of titanium white, because the paint can take more punishment than the bare illustration board. Also remember, before you start glazing, to let any underpainting dry completely, preferably overnight. Then you can be sure that you won't "pick up" any of it when you glaze over. That is, the underpainting won't mix with your glazes and make them "milky." One more point before you start painting: make sure that the line drawing is right; otherwise there's a good chance that you'll get so absorbed that you won't notice your drafting faults until it's too late.

Step 1. I begin with a watercolor sketch that I've made on the spot. I use Marabu watercolors because they allow me to quickly record the kind of visual information I need for the future painting. I want to take back to the studio a faithful rendition of the scene. I use a #7 pointed sable watercolor brush and from the beginning try to establish a faithful representation of the color and texture before me. Remember that I must sketch the textures of the wall alla prima—without any textural underpainting. I can use impasto and glazing in the finished acrylic painting. This sketch is only 6½″ x 9″, and I show it here squared off with white opaque lines. I'll use this grid to help me enlarge and transfer the sketch to the final painting surface.

Step 2. *Between Step 1 and this step, I've used the squaring off method that I described at the beginning of this book and enlarged the color sketch (Step 1) making a pencil line drawing from it on the 20″ x 30″ illustration board. Here, with the #6 flat and the #4 bristle bright, I reinforce the pencil outline with burnt umber acrylic everywhere except on the pots. On them I use the #5 pointed red sable for more accurate delineation. I paint in the entire composition using only two colors: Hooker's green and burnt sienna. These also give me a chance to see how the cool (Hooker's green) and warm (burnt sienna) areas are going to balance each other. Now I take the #20 flat sable and cover the vertical wooden wall of the entrance, the top of the bench, and the ground with the two colors. Next, I use my painting knife to apply a thick impasto to the stone wall with white acrylic straight from the tube. I pat the paint with the flat side of the blade to build up the wall's texture; I scrape with the edge of the blade to make its cracks. I've made no attempt to finish, but work quickly and broadly on all areas of the picture to cover its surface completely.*

Seascape with Opaque Watercolor

The demonstration in this project begins with a color sketch that I did on the spot. I've also done a pencil drawing on the spot that includes the elaborate detail of the scene that I want to record for use in the final painting which I'll render in opaque watercolor in the studio. If the weather doesn't allow you to do both the sketch and the pencil study on the same day, do one and come back later to do the other. But make sure you come back at the same time of day, so that light and shadows conform with your first sketch.

In the color sketch I simply want to faithfully record all the colors present so that I'll have them to refer to later back at the studio. I use opaque watercolor for this sketch, because the medium allows me to quickly and spontaneously capture the color and tones of the scene. In the studio I also use opaque watercolor for the finished painting, because it's one of the water-based media that allows me to build up thin layers of paint to achieve just the right hue and to amass the detail so characteristic of the magic realist approach.

For this project you'll need a drawing pad, tracing paper, and illustration board; the latter will provide the surface for the final painting. I've used a 14″ x 17″ Strathmore drawing pad #400-7 for the enlarged pencil drawing that I discuss in Step 2, an Aquabee tracing pad #524, and a 15″ x 20″ piece of Bainbridge illustration board #80, double thickness, regular surface, for the final painting. In addition, you'll need #3, #5, and #7 watercolor brushes, plus a #20 flat sable. You'll also need the following opaque watercolor palette: alizarin crimson, flame red, brilliant yellow, Winsor blue, permanent white, and ivory black. For the watercolor sketch I've used, once again, the Marabu watercolor paintbox.

Step 1. Coming upon this lovely spot in Nova Scotia, I immediately set to work to record it. Using Marabu watercolors, a Strathmore pad of paper, and a #10 flat sable brush. I use this watercolor sketch to help me remember the colors present when I'm back in my studio. My palette consists of alizarin crimson, yellow ochre, cobalt blue, raw umber, black and white. I also make a careful pencil study of the scene (which I haven't shown here) to record minute details. When using Marabu opaques colors, which are in cake form, I first moisten all of them by rubbing each cake with a water-soaked brush or a sponge. I begin the sketch by outlining shapes with very thin burnt sienna, using the edge of the flat sable brush. Then, to cover larger areas with color, I just turn the brush to its broad side.

Step 2. You remember in Step 1 (although I didn't show it) that I did a 16″ x 12″ pencil study recording the scene's most minute detail. Now I enlarge that study, using the "squaring off" method. Then on my illustration board I trace only the contours of the big shapes. These I fill in using flat tones which are mixtures of flame red and brilliant yellow. I use very thin paint and apply it with the #20 flat sable. The mauve of the buildings I create from a mixture of alizarin crimson and Winsor blue, adding black or white to create values. I stress the use of thin paint because I'd like you to remember that the magic realist technique consists of piling up thin layers of paint—whether opaque watercolor, egg tempera, casein, or acrylic—to achieve particular colors, tones, and textures. This especially applies to egg tempera. Let me stress another point. I couldn't have done the painting from either the color sketch or from the pencil study alone. I needed to refer back to the information that each had to offer.

Step 3. *Now I tape the 16″ x 12″ pencil drawing that contains all the detail over the flat color areas that I painted in Step 2. Then I trace the details from the drawing lightly in pencil on top of the large shapes. I use the wet-into-wet method to lay in the sky and the water; for them I use Winsor blue and alizarin crimson. On the boards of the barn in the foreground I use a drybrush technique to obtain their weatherbeaten texture. In black, I delineate the trusses that support the barn so that as I apply the shadow beneath the barn, I won't obliterate them. For the under-painting of the water I add a pinkish tone in the distance with a mixture of white and alizarin crimson. There's a bluish tone in the middle ground which is a combination of Winsor blue and white. In the foreground my water becomes a more gray tone—a mixture of alizarin crimson, Winsor blue and white. With an off-white, I begin indicating the shimmer and texture of the water, using the point of the #3 brush. Then, with the side of the #5 brush, I apply the texture of the shingles on the roof across my traced horizontal pencil lines. I also begin articulating the individual shingles. To convey their weathered and dilapidated condition, I take a damp sponge and tap with it to blur and soften them.*

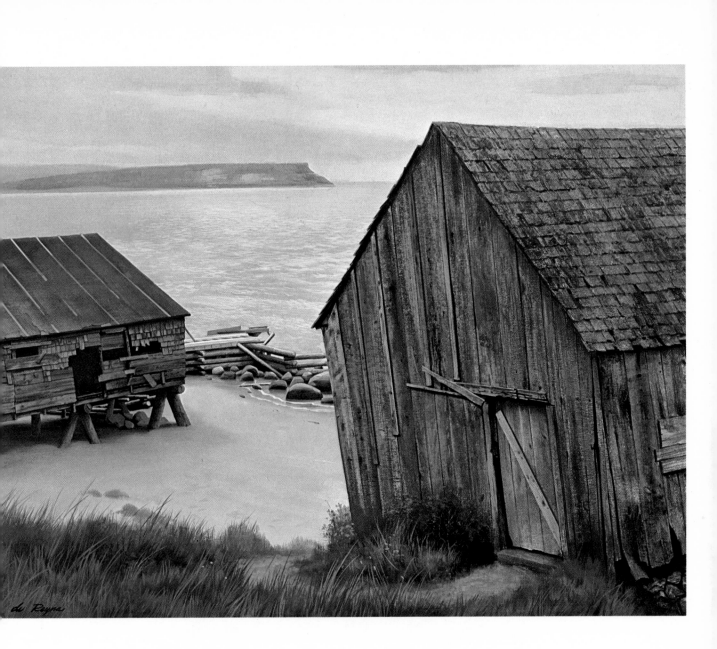

Step 4. What remains at this stage is a matter of sustaining the mood and the feeling that first prompted me to record the scene. I do this by rendering the details so characteristic of the magic realist approach. A good system to follow when working on the "grays" of the buildings is to distribute the mauve tones all at once (as I did in Step 2). Then successively apply all the yellows, all the greens, and all blues, to prevent having to mix these tints over and over again. I finish the sky, the water, and the barns in that order. Then I tackle the foreground. I use a mixture of brilliant yellow, Winsor blue, and white for the grass. I flip the #3 brush upward, just as the blades of grass grow, to render its detail. For the low bushes near the doorway I stipple color with my sponge. For the rocks in the water, I use mostly black and white with accents of flame red and brilliant yellow.

PROJECT 21

Seascape with Egg Tempera

For this project, I've done some on-the-spot watercolor sketches that you see here and on page 129. I'll discuss just how you go about choosing a sketch for development into a finished painting in Step 1. Of course, you'll also watch me develop an egg tempera painting in full color.

For the sketch you need watercolor paper and opaque watercolor. I've used an Aquabee Bristol pad #1171, size 14″ x 22″ and a Marabu box of watercolors, office pencils for sketching, and a 5H pencil for tracing. I've done the final tempera painting on Bainbridge illustration board #80, double thickness. You'll need watercolor brushes #3, #5, and #7, and the flat sable #20, plus small containers or a nest of china dishes with lids to hold the various egg tempera colors. Egg yolks are necessary to mix with the dry pigments. You'll need the following tempera palette: alizarin crimson, American vermilion, yellow ochre, raw umber, burnt umber, "thalo" blue, titanium white, and ivory black. Grumbacher Inc. makes good quality pigments. You can use other brands but make sure they're good quality. Do *not* use the so-called "Tempera" dry, powdered colors sold in one-pound containers—fine for children but not for serious work.

Sketch. *With this sketch I'm searching for a motif that incorporates beached boats. First I paint the rock formation, and then to add conviction to the textures, while the rocks are still wet, I scrape them with a painting knife. However, this sketch doesn't' really stimulate me.*

Step 1. *With these three boats, as Norman Rockwell says, "I heard a bell ring." I know this composition is what I've been searching for. Using the same watercolor palette and pad, I set to work. Here again I use the Marabu brand of watercolors. The three boats in this scene provide me with a ready-made composition. The boats provide the verticals and diagonals necessary to counterbalance the straight horizontals of the beach, the sea, and the sky.*

Step 2. *On returning to the studio, the first sketch I tackle is the one that has "rung the bell." I enlarge the sketch from 14" x 8" to 26" x 16". Now, I concentrate entirely on the correct construction of the boats. I refine the shapes of the puddles, add the surf to the quiet bay, and introduce the grass in front of the foreground boat. I draw these details with an office pencil in line only because this line drawing is all I need to trace onto my illustration board. I've already solved color, mood, and the tonal scheme in my watercolor sketch (Step 1).*

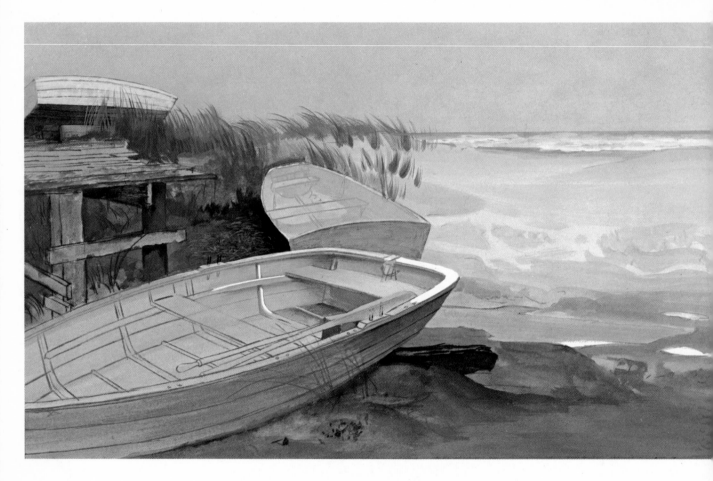

Step 3. *After tracing the enlarged drawing onto my illustration board, I give the sky its first thin underpainting with a mixture of "thalo" blue, white, and a touch of burnt umber. I use my #20 flat sable for this and work the sky into the sea, the grass, and the boat at the upper left. I can redefine these objects later with thicker pigment. Note the stern of the foreground boat. Here you can see the approach most characteristic of magic realism. First I cover the entire boat with thin washes of white to which I've added a "whisper" of "thalo" blue and raw umber. Then, when these washes dry, I go back with thicker pigment and define texture and add detail. I use the same mixture on the sea that I used on the sky with the addition of a touch of alizarin crimson. The grass is a combination of "thalo" blue, yellow ochre, and white in the light areas; for the shadows in the grass I use thalo blue, raw umber, and black. To balance the somber tones of the dock I use a mixture of American vermillion, black, and white on the other two boats.*

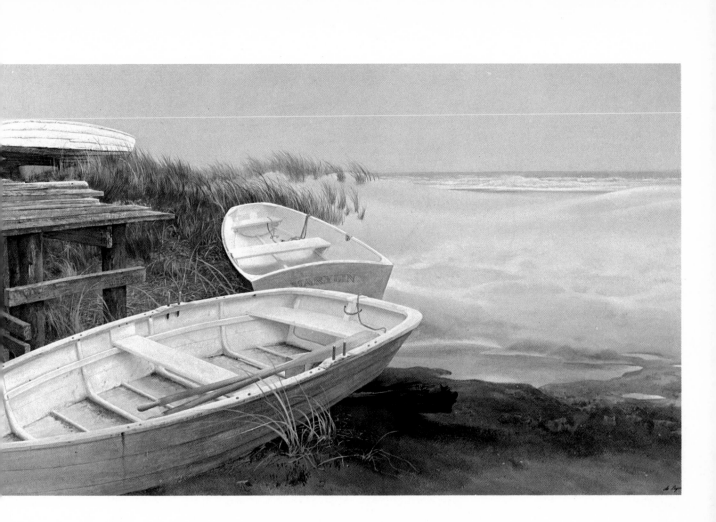

Step 4. *By the time I reach this last stage in a painting, I want to relax, and even contemplate starting another. But I don't. I mention this in case you feel the same urge to slough off. I have done it, to my regret, and even though I may return to the painting a couple of days later, I'm not in the same mood and have lost that critical momentum so necessary to good work. You can see that I've added a great deal of texture everywhere. On the other hand, I smooth out the sand dunes using drybrush and very thin pigment. Then I work on the grass, paying particular attention to shadows cast by the indirect lighting of the overcast sky. Notice that these shadows are diffuse, without any sharp edges, just like those shadows within the boats. Then I go on to the puddles. To get their shiny surface I work wet-into-wet. I use thicker mixtures of "thalo" blue and yellow ochre with black and white to get the right shade for them. On the shadows and puddles I use #3 and #5 watercolor brushes by Winsor Newton. I mention this brand because the same number made by another manufacturer is usually a smaller brush.*

Working with Casein from Reference Sources

The casein medium requires practice to discover its unique and particular behavior. Even though it resembles opaque watercolor, it's altogether different as you discovered in Project 18. I'll be using a Masonite panel as my surface for the final painting. The Masonite must, of course, be primed with gesso (see the Materials chapter). Be sure that you sand the gesso surface between coats. The coats of primer should be brushed on in alternate directions; that is, you brush the first one on horizontally, brush the second on vertically, and so on.

In addition, this demonstration is a good exercise in painting from memory and other reference sources. Personally, I rarely paint from reference sources because it's the direct interaction between nature, a still life, or a model herself that inspires. However, imagination and memory can provide useful influences.

For your preliminary watercolor sketch you'll need a slant-and-well palette, butcher's tray, opaque watercolors, and also sketching paper. For the finished casein painting, you'll need a piece of 14″ x 16″ Masonite board, "Liquitex" prepared gesso, and a 2″ housepainter's brush. You'll also need rough and smooth sandpaper, office pencils, and a 5H pencil. You'll need the following casein palette: alizarin crimson, yellow ochre, ultramarine blue, burnt umber, titanium white, cadmium yellow light, and ivory black. In addition, you'll need the usual painting knife, #3, #5, and #7 watercolor brushes, and the #20 flat sable. As a rule, bristle brushes are used with this medium, but for the technique I'm demonstrating here, it's better to employ the watercolor brushes I've mentioned.

Step 1. This is my only work that hasn't been inspired by nature, but by another painting. I saw an artist-friend's painting that impressed me so much that I had to re-create it to shake it from my mind. First, I prepared a gesso panel, using a 2″ thick piece of Masonite, 14″ x 16″, and coating it with Liquitex gesso. I've explained this process in Project 13. Then while the last coat of gesso dries, I dash off the sketch (6″ x 7″) that you see here, using Marabu watercolors and my Srathmore pad. For the impasto on the walls, I use Designers' white gouache, a #5 brush, and my painting knife. My friend's painting was horizontal, but I deliberately make mine vertical, because my intention is not to ape my friend's work, but to seize upon the feeling he's captured.

Step 2. *With an office pencil I draw an enlarged version, 10" x 12", of my color sketch. Then I trace this drawing onto the Masonite board with the 5H pencil. Here you can see that I begin apply titanium white casein straight from its tube, using my painting knife. I apply it to the walls and the ceiling, but take care not to kill the pencil outline. Be sure to pat with your knife as well as drag its blade over the thick paint to achieve the texture you desire. Make the texture of the wall as bold and as rough as possible. Casein, even when it's thick, dries quickly to the touch, but I prefer to let mine dry for hours—sometimes even overnight if I have something else "in the oven." As I work on the walls, I try to recall characteristics of plaster walls I've seen. You see, the artist is always observing and filing away things that eventually will be used.*

Step 3. *After the impasto of Step 2 is dry, I glaze it with a mixture of black, yellow ochre, and ultramine blue, using the #20 flat sable brush. But I notice that the impasto picks up and mixes with some of the areas, making them milky. To avoid this effect I give the walls a coat of Liquitex matte medium (a medium used when painting with acrylic) to seal the impasto on them completely. The medium dries instantly, and then I resume my work. I've worked the impasto and the glazing into the rafters and the legs of the table, but I can easily regain the contours of these objects by retracing my line drawing.*

Step 4. *Here, I subdue the rough textures on the walls because I think they call too much attention to themselves. It's much easier to smooth over rough textures than to make smooth ones rougher by applying impasto all over again. I smooth out the walls by using thicker pigment which I spread evenly over the impasto. However, before I do this, I also scrape off with a razor blade some of the protuberances of white casein that thrust out too far. In my friend's drawing the view through the window was just of clear sky. To give my painting more interest, I look out my own window and paint the tree you see here. I recover the shape of the rafters and the table by retracing my line drawing. Then I go on to the pitcher and bowl and finish them, using the #3 brush with yellow ochre, ultramarine blue, and black for the off-white modeling. For the bands on the pitcher I use alizarin crimson touched with blue and white. If you fine it difficult to use the tip of the brush to paint a thin line, then by all means, switch to a #1 brush to do the stripes. I've done the lines on the floor employing the ruling method that I explained in Project 5. If you haven't practiced it, I urge you to do so now. It's invaluable to good draughtsmanship.*

PROJECT 23

Still Life in Egg Tempera

When I painted the still life for this demonstration, I had to stop in the middle of it to finish another commission. Later, I went back and continued the demonstration. It's better not to interrupt work on a picture until it's finished, but there are times when it's unavoidable. When working from small elements, like the nuts in this still life, set the arrangement close to you so that you can easily observe their minute detail. Also be sure to mark the exact position of the objects before they're removed, so that you can reposition them precisely later on.

You'll need the following materials for this demonstration: light gray-green mat board with white bond paper on its reverse side, and illustration board. I use "Crescent" illustration board #114, and an Aquabee bond paper pad #664H, size 19″ x 24″ which I use for my sketch. You'll need #3, #5, and #7 watercolor brushes and the #20 flat sable. For the tempera you'll need egg yolks and a set of china dishes to hold the tempera; mine are 2½″ and 3½″ in diameter and I use the larger ones when I need a larger amount of color. For the color sketch you'll need the following opaque watercolors: Havannah lake, yellow ochre, Winsor blue, permanent white, and ivory black. You'll also need Grumbacher's dry pigments: Mars red, yellow ochre, "thalo" blue, titanium white, and ivory black.

Step 1. I spotted the objects for this still life on my kitchen counter and I was instantly taken with the color and texture of this subject matter. So I've brought these items to my studio; to simulate the lighting in the kitchen, I now set up a 100-watt spotlight above and to the left of the bowl and vase of flowers. I place the nutcracker in several positions and finally put it where you see it, because I want the objects to overlap one another to create a unified composition. I set up the still life on the green side of a piece of mat board because it's about the same color as the top of my kitchen counter. To make the color sketch that you see here, which is 9″ x 8″, I use #5 and #7 brushes and paint on the reverse (white) side of another piece of green mat board.

Step 2. *The next thing I do is to enlarge and true up the construction of the elements of the still life with an office pencil on a sheet of 664H Aquabee bond paper. Then I add light and shade with a #314 "draughting" pencil because I want to recapture the tonal scheme that I'd seen in the kitchen and have a permanent record of the disposition of the shadows. Next I trace only the line structure of the objects onto an 18" x 16" piece of illustration board. Then I start to lay in large areas of color using very thin paint mixed with very little white. I use yellow ochre, Mars red and black on the wall. The green counter is a mixture of "thalo" blue and yellow ochre, with a touch of white in the light and black in the shadows. For the bowl and nuts I use Mars red, yellow ochre, and black. I use mostly the #20 flat sable brush since I'm now working on an 18" x 16" area. I prepare a goodly amount of the green in one of my 3" china dishes because I plan to use green tones later; I'll be able to easily make the green lighter or darker without having to prepare the original mixture over again. Note that I don't try to hide my brushstrokes at this stage. I'm only interested in covering the entire surface as quickly as possible so that I can judge the values as I proceed.*

Step 3. *After painting the background with yellow ochre, white and black, I start indicating some of the flowers. I'd planned to make the window frame pure white but it became too prominent so here I gray it down. I start to define some of the nuts with the #3 brush and a mixture of Mars red, yellow ochre, and black, adding water by dipping into the water jar and then into egg tempera. If I think that perhaps I'm diluting the color too much, I add a few drops of yolk to that particular dish to firm up the paint. Then I continue with the #3 brush and work on the flowers with Mars red, yellow ochre, black and white. The counter begins to be too vivid, so I start to lighten its green. Usually I rest my hand on a mahl stick. However, for very minute detail, I place a sheet of paper under my hand so I won't mar the painting. I paint the vase for the flowers with gray, using white for highlights. I begin to indicate shadows behind the flowers with a mixture of ultramarine blue, yellow ochre and black. At this stage there's a phone call. My friend, Mr. Guy Rainsford, wants to know if I'm free to do his portrait. I ask him to give me a week's time, and during that week I paint my daughter's portrait (which you can see in Project 24) to "warm up." But before putting away the still life that I'm using here, I mark the position of the objects on the green board with a pencil so I'll know exactly where they were placed.*

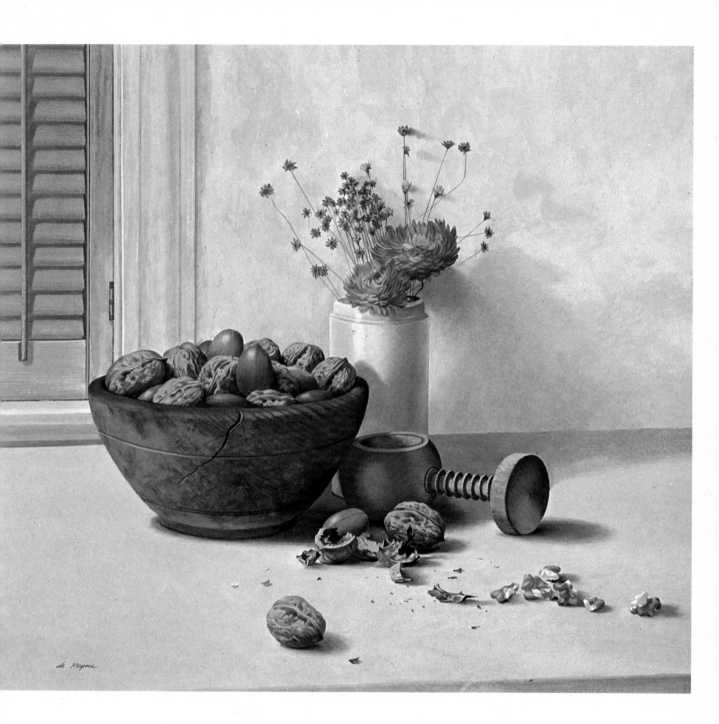

Step 4. *It's been almost a month since I put away Step 3. During that time I've done the two portraits I mentioned and we shall do them in the next two projects. But now let's finish this one. On resuming the work, naturally, I have to mix all my tempera colors anew, including the green that served as a basic tone on the counter. First, using mostly drybrush, I do the shadows behind the small flowers with ultramarine, yellow ochre and black. With this same mixture I also do the shadow on the side of the vase but I add more blue. The cast shadow under the bowl, the nutcracker, the nuts, and even the shells are a mixture of green, Mars reds and black. Then I go to the bowl and apply the stains on it with the side of the brush and yellow ochre plus white. I notice that the bowl needs warming up so I give it a glaze of yellow ochre. I paint the shutter on the window next, rendering the straight lines with my ruling method. Then I move to the flowers and give them the last touches with the Mars red and yellow ochre and the #3 brush. And last, I do the tiny bits of shell on the counter and the nut meats with a mixture of yellow ochre and Mars red, adding white to it for the lights and black for the shadows, and a #3 brush.*

PROJECT 24

Female Portrait in Opaque Watercolor

If there's no young member of the family at home, ask a friend to pose for you, and make the sittings as brief as possible. Young people are restless, and even though I've never found one that wasn't flattered when asked to pose, they soon discover that it's no fun. Suddenly they're aware of countless commitments they must discharge.

Even though I have excellent natural light available in my studio, I've decided to do this portrait for this demonstration under artificial lighting because, chances are, these are the conditions under which you'll have to work. I place a 100-watt spotlight above the model's head, slightly in front and to the right. At her left I place a 60-watt spotlight at about the same level with her head. You can use one light source if you wish, but make sure there are no strong separations of light and shade on the model's face.

For this project you'll need a pad of drawing paper, 11″ x 14″. I use an Ad Art pad #307. Also you'll need several office pencils and a 5H pencil for tracing. For the opaque watercolor painting, watercolor brushes #3, #5, and #7, and the #20 flat sable are needed. The opaque watercolors needed are: alizarin crimson, flame red, yellow ochre, Winsor blue, raw umber, burnt umber, ivory black, and permanent white. You'll need a 20″ x 15″ piece of double thickness (I use Bainbridge) illustration board for the final painting. Most important of all, you must have a young person who's willing to pose.

Step 1. To begin, I first do a pencil drawing on the Ad Art #307 pad with an office pencil. With this sketch I work only for correct construction and modeling. The sketch (which isn't shown) measures 8″ from the top of her head to the bottom edge. Check Step 1 of Project 11 for this pencil approach. Then I trace the outline of this drawing onto the illustration board. Next, while still observing the model, I prepare a flesh tone, using a combination of flame red, yellow ochre, and white, that will serve as the middle value for her face and neck. I apply this color with a #7 brush, and then mix a light blue tone on the butcher's tray for the background. First, before applying it, I dampen the surface of the board. Then I spread the blue paint with a #20 flat sable quickly in all directions to get an even tone.

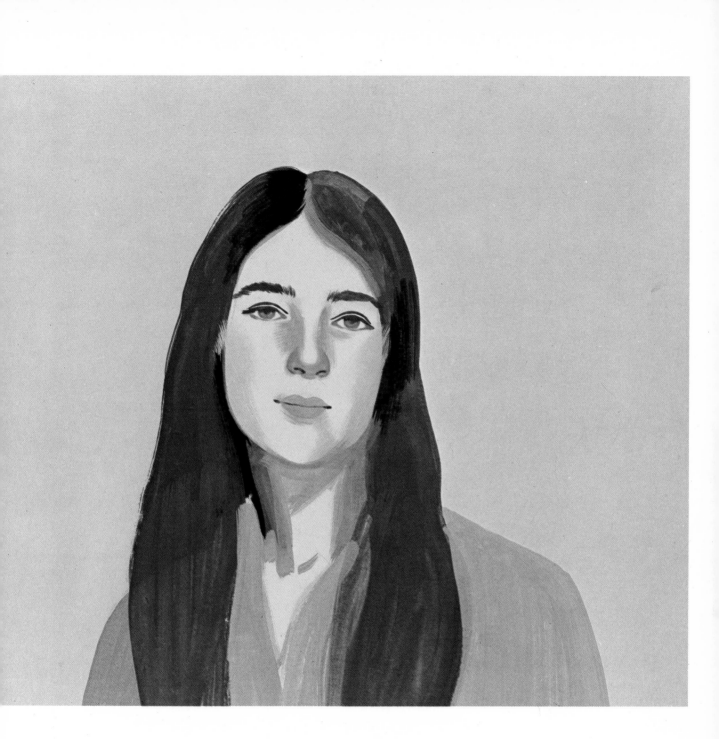

Step 2. *The traditional way of setting up a background for a portrait is to place a screen behind the sitter. Then you tack a piece of cloth or tape a piece of paper in the desired color on it. You can dispense with this, of course, and just select a color that suits the subject for the background of your painting. Here, my thinking was: young girl equals clear skies, bright and shining prospects, unclouded vistas, and all that sort of thing. This is logical, intellectually, but visually my background turned out to be too cold. So here I go over the background I began in Step 1 with a mixture of mostly white, a touch of raw umber, and just a whisper of Winsor blue. Then, following the penciled outline, I paint in flat tones for the hair, using raw and burnt umber. For her blouse, I use alizarin cumson, Winsor blue and white. I establish her features and begin to create shadows on her face using a drybrush technique. Checking the model, I find the darkest values to be at the top of her head and on her hair next to the sides of her face. In these areas I add black to the raw and burnt umber. I'm not yet concerned with the character of edges, except for the soft transitions on her face. I execute these with the #3 brush. I fan this brush and sweep lightly over the initial flat flesh tone.*

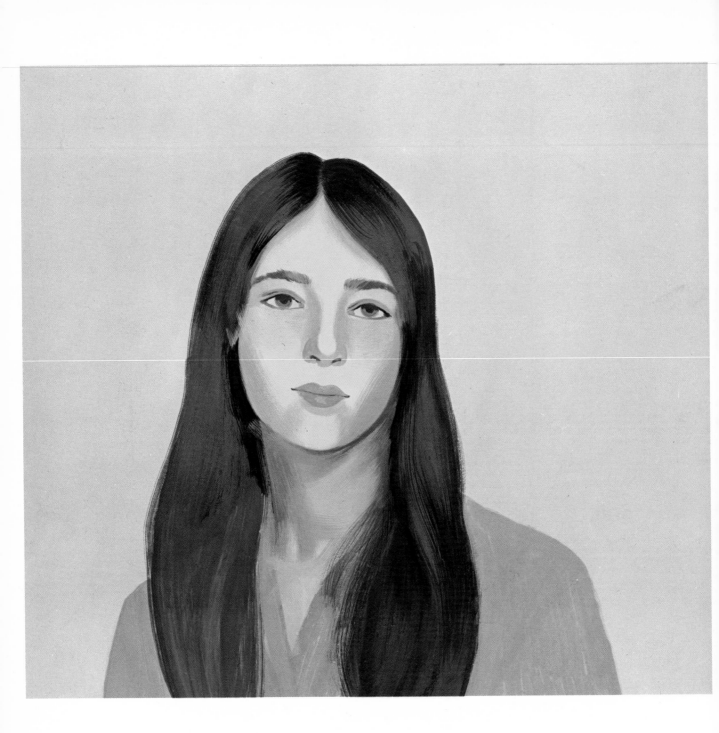

Step 3. *I'm not satisfied with the background yet. Here I make it still a bit lighter and take it into the contour of the face. This is a good example of how easy it is to change a color when working with opaque watercolor. I'm glad I could demonstrate this, but I confess that I "blew it" in the first two steps, probably in my eagerness to start painting. Again, working from the model which I place about four feet away from me, I regain the contours of the face and start to render the hair using drybrush in long sweeps with the #5 brush. For hair that's in the light, I use yellow ochre and white. I add black for the hair that's in shadow. Then I work on her eyelids, her cheeks, her chin, and her neck to carry the picture forward at the same pace. I use flame red and white for her lips and Winsor blue, yellow ochre, and white for her irises. As I model the face and neck, I swing the strokes beyond the contour of her face into her hair without fear of disturbing a finished area. If I had finished her hair first, then I'd feel constrained about working on her face, because I'd be afraid to ruin her hair.*

Step 4. *Having established the color and the value of her hair, I move to her face and finish it completely. The posing becomes easier for the model as I go along, because since the drawing is already established, all I'm checking now is her coloring. I've demonstrated this procedure because it's a very practical approach. First, you can focus all attention on capturing gesture and likeness in the pencil drawing, without worrying about color. Then you can tackle color as a second problem separate from the first, and thus the entire job becomes half as difficult. I go on to her blouse and work it slightly into her hair, which I finish last. I define strands of hair with drybrush over the blouse and against the background over the left shoulder. I add highlights on the tip of her nose, her irises, and her mouth with white and a touch of yellow ochre. I also add such finishing touches as upper and lower eyelashes. I use black and burnt umber for these. I define the separation of her lips with alizarin crimson and burnt umber.*

Male Portrait in Egg Tempera

In this demonstration you'll learn how to tap your brush and use short strokes in rendering, as though the brush were a pencil, which is the traditional way of executing a tempera painting. You'll also put to use again the technique I demonstrated in Project 19 which consists of underpainting with burnt sienna and green to "nail down," or establish, the drawing and its tonal scheme. There'll be certain stages after you begin to apply the local color over the underpainting when your work will look so dreadful that you'll be tempted to throw the blasted thing away. Don't! The painting always looks like this at the halfway point when you follow this technique.

You need the following surfaces for this demonstration: a 19″ x 24″ vellum tracing pad, a drawing pad, and hot-pressed illustration board. You'll use office pencils for drawing and the 5H pencil for tracing. Your brushes will be #3, #5, and #7 watercolor brushes, and the old faithful #20 flat sable. To hold the tempera colors, you'll need a nest of china dishes (or other containers), egg yolks, and dry pigments. I use Grumbacher pigments in the following colors: Mars red, yellow ochre, "thalo" blue, titanium white, and ivory black. For the underpainting, you also need burnt sienna and viridian. For the preliminary color sketch you'll need some opaque watercolor in yellow ochre, Winsor blue, and Havannah Lake, which is a fugitive color, but just for the sketch I shouldn't worry about it.

Step 1. *Now, after doing my daughter's portrait as a warm-up exercise, I'm ready to tackle my commission portrait which I demonstrate here. In the previous project I did a pencil drawing first, but here I start with a color sketch because I knew that my friend (and "brother of the brush") wouldn't be at my beck and call for the entire portrait. My purpose with this color sketch that you see here is to get both proportion, composition, and color at one "go." I use the three opaque watercolors that I've mentioned (Havannah Lake, Winsor blue, and yellow ochre) on a vellum sheet. I use the vellum paper because it takes this medium very well. Notice that here I've used only one light source to create definite and strong separations of light and shadow that will bring out the rugged character of my sitter's face. With the #3 brush I begin the contour of the head and the placement of the features in line, much as I do in the pencil drawing of Step 1 of the previous project. For these contours I use thin paint.*

Step 2. *I've traced onto a 16″ x 14″ illustration board only the linear construction of the portrait, after refining it on a piece of Ad Art paper placed over the color sketch. After tracing the drawing to the board, I strengthen the outline with an office pencil. Next, I mix powdered viridian pigment with egg yolk in one of my china dishes. In another I mix up burnt sienna pigment and egg yolk to create my tempera. Then I begin to paint in thin washes. I dip my brush first in the water jar and then release the water on the tray; then I mix some color from a dish into the puddle of water. Since the correct (no, let me say, exact) placement of the features is so important in a portrait, I "nail" these down first. I use deeper values than the ones I see, so that when I begin applying local color (the color of the flesh, the hair, and the clothing) I won't lose the drawing. I've allowed some pencil lines to remain visible on his jacket and on his face to show you the line drawing I'm painting over. Remember that here it's more important to secure the details on the face than to strive for correct values and proper color. This is only the foundation over which you'll apply the true color and values, using your color sketch as a guide.*

Step 3. *With the #5 brush I start applying local color in the light area of the face to kill the white of the bare paper. I use a mixture of white, Mars red, and yellow ochre for this. I begin spreading the dark color of the background with the #7 brush. For it, I'm using mixtures of Mars red, yellow ochre, "thalo" blue, titanium white, and ivory black. I try to stay close to the color scheme on my sketch (see Step 1) but I don't hesitate to make a color more vivid if I feel it will improve the picture. Remember that in egg tempera you must work thinly. When working in opaque watercolor you can pick up pigment from the butcher's tray with a damp brush even after it has dried. However, you cannot dissolve egg tempera again once it has set; you have to mix up a new batch.*

Step 4. *I continue to glaze with thin layers of paint to deepen the shadow area of the face. I use mixtures of Mars red, yellow ochre, "thalo" blue, and black for this. If the shadows turn out too hot, you can glaze them with a mixture of yellow ochre and blue to neutralize and gray them. Note the wide range of hues that you achieve with only red, yellow, and blue, plus black and white. Here instead of the long, light, smooth strokes that I used for Project 24 to depict a young face, I use short, choppy strokes with thicker pigment to depict the wrinkles, crevices, and sharp configurations that life has carved on this eloquent face. I use mostly the #3 brush on the head. For the turtleneck I use a mixture of "thalo" blue, yellow ochre, black and white with a #5 brush. I use the same brush for the jacket with a mixture of "thalo" blue, Mars red, and yellow ochre. I use the mixture of black, yellow ochre, and Mars red for the background and my #7 brush. Remember to leave the minutest details until the last. Here they consist of the strokes of gray on the eyebrows, the moustache, and on the temples.*

Child's Portrait in Egg Tempera

In this demonstration you'll get more practice in creating smooth flesh tones. You'll also see me change some of the actual colors of the original model and color sketch to make them fit the requirements of this particular painting. Most important, I add some props to this portrait (the book and Raggedy Ann doll) to make it more expressive of the sitter's personality.

Throughout the book, I've suggested that you copy the steps of the demonstrations—not because I want you to emulate my style—but because I want you to get practice in a particular technique and the sequence of steps that such a technique might demand. But now that you have tried and, I trust, mastered these various techniques, I hope you will go off on your own and explore variations on these techniques, as well as new subject matter.

For this demonstration, you'll need the following surfaces: vellum for the preliminary watercolor sketch, tracing paper, and a 16″ x 20″ piece of illustration board for the final egg tempera painting. I use an Aquabee vellum pad #565 and Bainbridge illustration board #80. You'll also need office pencils, and the 5H pencil for tracing. For the preliminary watercolor sketch, you'll need the following watercolor palette: alizarin crimson, yellow ochre, turquoise blue, raw umber, burnt umber, vermillion, black, and white. I use Marabu opaque watercolors. For the finished tempera painting you'll need egg yolks, a nest of china dishes (or other containers for the tempera paint) and the following palette of dry pigments: alizarin crimson, American vermillion, yellow ochre, "thalo" blue, viridian, burnt umber, raw umber, ivory black, and titanium white. In addition, you'll use watercolor brushes #3, #5, and #7.

Step 1. *This preliminary drawing measures 8″ from the top of her head to the bottom of Raggedy Ann's left foot. With this drawing, I'm searching for correct proportions and pleasing composition, as well as a "likeness" and an interesting visual statement. At first, I was going to emphasize Betsy and her book, but walking through my daughter's room, I spotted her Raggedy Ann doll. Straightway I knew the picture would be more interesting if "Ann" sat listening to Betsy's "bedtime story." I'm pointing out something to remember: an artist's first conception, as forceful or engaging as it may seem, should be examined for more interesting possibilities.*

Step 2. *Here I do a preliminary watercolor sketch of Betsy. You'll notice that in this demonstration I'm once again separating the drawing and construction problems from the color problems, because I believe it's more sensible to sift out the respective components that make up a painting. Each component remains intact for future reference. If the color in this sketch isn't satisfactory, I can easily remove the vellum on which I've done it, and place another sheet of vellum over the pencil drawing. Then, I can begin a fresh attach once again on the color problem alone. Using Marabu watercolors, I paint the "nighty" in pink (for girls) even though it was actually white with tiny pink flowers. However, I know that such a pattern against the illustrations on the book pages would make the picture much too "busy." I introduce a gray vignetted shape behind my sitter to create better unity and to detract attention from the legs of the chair that otherwise would have appeared too stark.*

CHILD'S PORTRAIT IN EGG TEMPERA 149

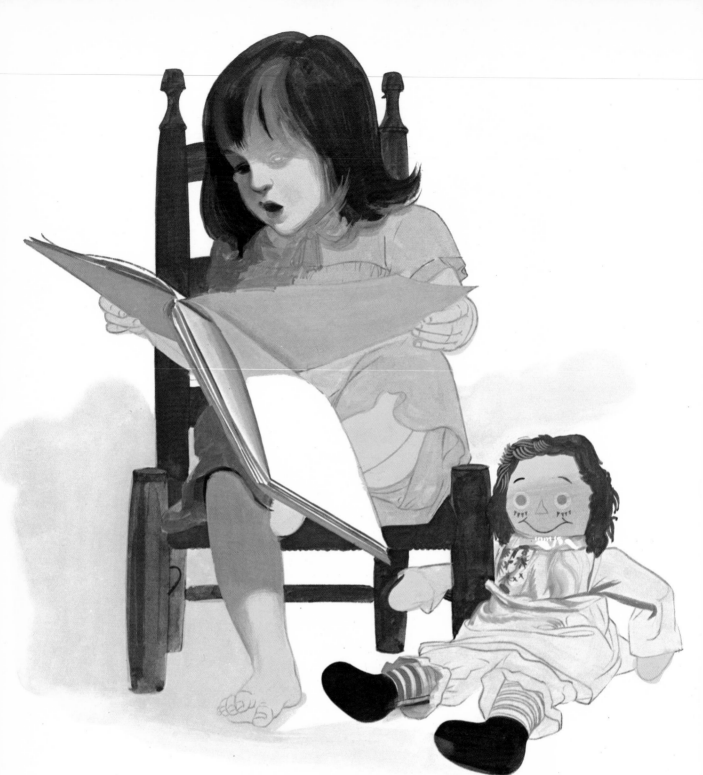

Step 3. *Here I first enlarge my preliminary pencil drawing (see Step 1) to 14″ and trace it onto my illustration board. To enlarge the drawing I use the "squaring off" method. I only transpose the large line structure, since my color sketch will be my reference for light, shadow, and color. Once my pencil line drawing is established, I begin to lay in my first washes of color. Notice that I place the darkest value on her hair. For this tone I use black and yellow ochre. The lightest values in the painting are the pages of the book. For the present, I leave the surface of the board showing through to establish this value. Pay attention to edges at this stage. The chair (done with yellow ochre, black, and white) and the book (done with "thalo" blue, yellow ochre and white) have firm contours. The shading on her face, the rendering of her hair, and the folds on both dresses are soft. For Betsy's dress I use alizarin crimson, yellow ochre, and "thalo" blue. For the gray behind the figures, I mix "thalo" blue, yellow ochre, and much white. I achieve the soft edge of the gray vignette by first wetting the area with clear water. Then I apply the gray paint with the #20 flat sable.*

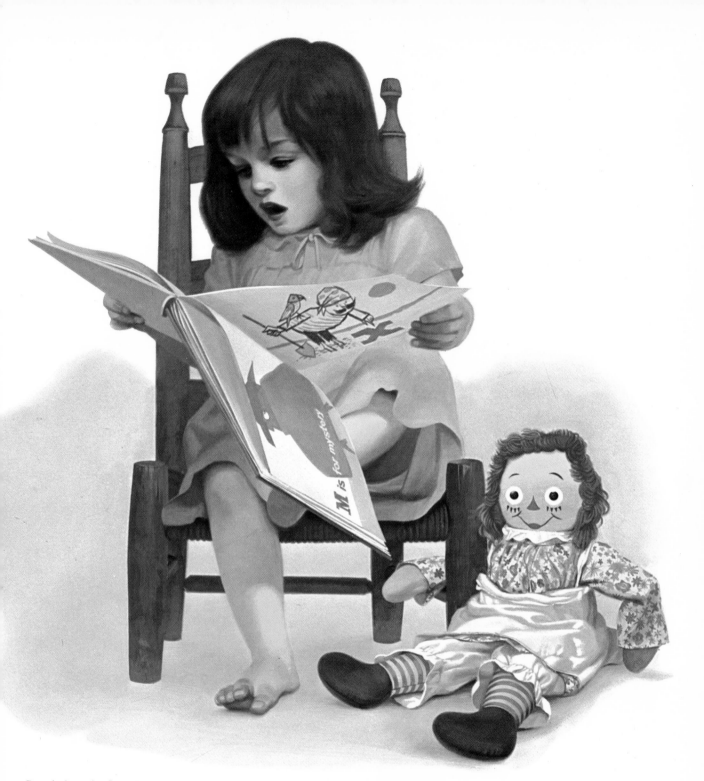

Step 4. *Over the flat color washes, I begin the definition of the hair using a #3 brush and a mixture of yellow ochre and raw umber. I add white to this for the lights and black for the darks. I model the flesh tones using sweeping strokes with a well-fanned brush. I'm adjusting the color of her lips to the pink of the gown. If they threaten to get too red, I neutralize and gray them with a touch of green or blue, but if they get too gray then I add red to the mixture on the tray. When a certain mixture is right I apply it to other areas of the same color and value. The flesh tone (a mixture of burnt umber, yellow ochre, and white) under her left leg, for example, was also applied to her right arm and to the shadow on her right foot. Once the basic tone is set down it becomes easier to darken or lighten a portion of it to give form. The sequence in rendering, working "from the background forward" is: the chair, the little girl, and then the book. Then I paint the blank pages in their proper value, and then the illustrations on them. Next I do the folds on Ann's dress; for the flowers on the top of the dress I use "thalo" blue, yellow ochre, alizarin, crimson, viridian, and white. Just remember that the thing "behind" is done before the thing "in front." I purposely left this project until the last because it bristles with problems—such as rendering folds and modeling delicate flesh tones—but I'm confident that with the knowledge you have gleaned, they'll hold no terrors.*

Winter Silence. 9¼″ x 10¼″. Opaque watercolor on mat board. Collection of the artist.

A Parting Word

My teaching here is done. I've described the media and procedures that allow you to paint in the "magic realist" manner. My purpose has been to equip you with the means to communicate whatever you want to say as an artist. But remember that technique without content is mere craftsmanship. The history of art has shown that it's a poor teacher who isn't excelled by his student. Without being blasphemous I say, by God, I'll be bitterly disappointed if you don't continue to forge ahead.

Suggested Reading

Blake, Wendon. *Acrylic Watercolor Painting.* New York: Watson-Guptill Publications, 1970.

Doerner, Max. *The Materials of the Artist.* New York: Harcourt, Brace and Co., 1949. London: Hart-Davis, 1960.

Herberts, Dr. Kurt. *Artists' Techniques.* New York: Frederick A. Praeger, Inc., 1958.

Mayer, Ralph. *The Artists' Handbook of Materials and Techniques.* New York: Viking Press, 1943. London: Black, 1950.

de Reyna, Rudy. *How to Draw What You See.* New York: Watson-Guptill Publications, 1972. London: Pitman, 1972.

————. *Painting in Opaque Watercolor.* New York: Watson-Guptill Publications, 1969.

Laning, Edward. *Perspective for Artists.* New York: Grosset and Dunlap, Inc. 1963. London: Pitman, 1967.

Vickery, Robert, and Cochrane, Diane. *New Techniques in Egg Tempera.* Watson-Guptill Publications, 1973. London: Pitman, 1973.

Index